Asian Art

**Selections from the Collection of Mr. and Mrs. John D. Rockefeller 3rd
Part II**

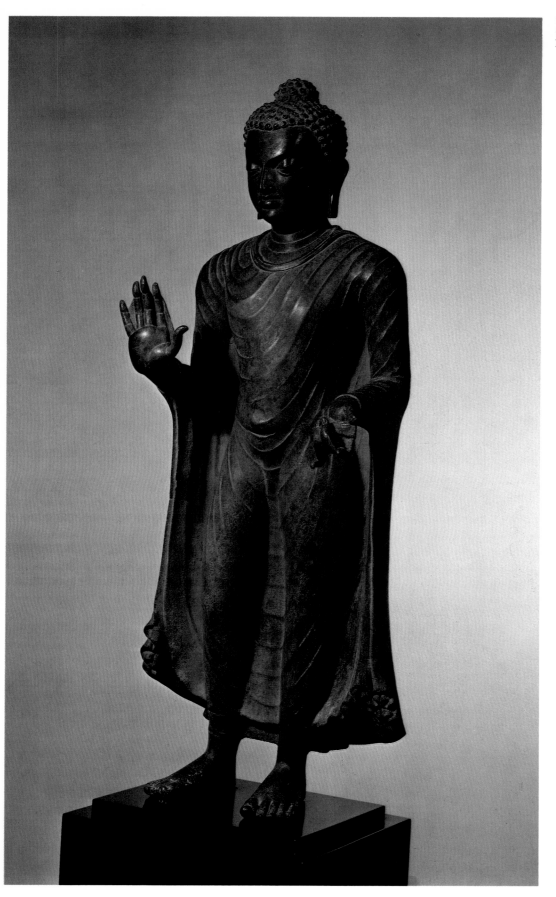

1. *Standing Buddha.* India;
Gupta period, 320–647.
Bronze; H. 27 in.

Asian Art
Selections from the Collection of
Mr. and Mrs. John D. Rockefeller 3rd
Part II
by Sherman E. Lee

Photographs by Otto E. Nelson

The Asia Society, Inc.
Distributed by New York Graphic Society Ltd.

Asian Art, Part II: Selections from the Collection of Mr. and Mrs. John D. Rockefeller 3rd, is the catalogue of an exhibition shown in the Asia House Gallery in the winter of 1975 as an activity of The Asia Society, to further greater understanding between the United States and the peoples of Asia.

An Asia House Gallery publication

Contents

Foreword

In 1970, when Asia House Gallery was observing its tenth birthday, it was most appropriate to celebrate the occasion by exhibiting selections from the collection of Mr. and Mrs. John D. Rockefeller 3rd. In his foreword to Sherman Lee's catalogue of that exhibition, Gordon Washburn, former director of Asia House Gallery, emphasized the essential role that Mr. and Mrs. Rockefeller had played both in the foundation of The Asia Society and in their generous, continuing support of it. Now, some four years later, another even more significant moment has come to the Gallery which especially calls for a look at another part of the collection. This occasion, of course, was brought about by the Rockefellers' announcement last February of their intention to give the collection to The Asia Society.

Until that moment, the Society could look forward only to the continuation of the temporary loan exhibitions which have been organized by the Gallery three times a year to bring the great variety and quality of Asian art before the public. Now our obligations will become easier to achieve because magnificent objects will be on permanent display in newly constructed galleries. This further exposure to the Rockefeller collection has a deeper meaning. It should now be studied and appreciated in the context in which Mr. Rockefeller himself placed it when he made known his gift. He expressed the hope that the collection would "strengthen and make more effective the work of the Society . . . at a time when . . . we have the opportunity of developing a new and more creative relationship with Asia."

It is especially interesting to note that the majority of the objects seen here were acquired since 1970, and in a comparison between this exhibition and the earlier one, some basic similarities as well as differences can be noted. These are described by Dr. Lee in his preface. It is important to reemphasize something of the history and philosophy behind the collection itself.

Others who have exposed themselves to the passions and temptations of collecting will recognize a familiar pattern of evolution as the Rockefeller collection has grown over the twenty-four years since the first acquisition was made. Slowly, and perhaps somewhat unexpectedly, it engaged them. At first it was only a small group of objects that had been purchased to enhance personal lives in home and office, but it gradually and inevitably became a larger, more demanding presence. It came to need more space, special care and attention, and the services of a full-time keeper. Requests for photographs, loans, and documentation arrived in increasing numbers. Finally, the all-important decision of what was ultimately to become of the collection forced itself upon Mr. and Mrs. Rockefeller, and it is a tribute to both of them that they found such a meaningful and far-sighted solution.

The fact that the ultimate destiny of the collection has been decided should not lead to the conclusion that it is now complete. It is still a living entity; additions and refinements will continually be made even after it comes into the ownership of The Asia Society, thanks again to the foresight of the donors. We present here a nucleus of the collection as a whole and an indication of the directions it will follow in the future.

In the face of all these changes and new obligations, the collection has steadfastly maintained its personal flavor, reflecting the catholic tastes of two individuals. Not all the cultures of the vast Asian continent are represented, but there is emphasis on those areas from Afghanistan to Japan which were familiar to Mr. and Mrs. Rockefeller through their extensive travels. Objects were acquired, Mr. Rockefeller says, "not only because of their beauty and appeal, but also because they served as constant and tangible reminders of the countries and peoples visited." Theirs, then, is not a museum collection in the sense that it seeks to satisfy a universal aesthetic or to illustrate various aspects of art and style. The basic demands for quality and excellence have been met, but it is in its intimate expression of personal tastes and contacts that it makes its most significant statement.

Mr. Rockefeller has expressed his wish that the collection be used to serve as a touchstone for all of the activities which will be carried on by The Asia Society. In this way, he hopes that some of the meaning it has had to him and to his wife can be transmitted to others. As each object has been called upon to "stir and lift" these remarkable collectors, so the entire collection will stir and lift all who come into contact with it.

Allen Wardwell
Director, Asia House Gallery

Introduction

This second selection of seventy works from the Rockefeller collection follows an exhibition of seventy other objects from the same collection which were shown at Asia House Gallery in the fall of 1970. At that time by no means all of the worthy works were shown. The collection has grown in the intervening four years and in the course of this development not only has its overall quality been maintained but it has been strengthened in its depth and variety. Equally important, the status of the collection has changed from that of a private assemblage to one officially committed to public display at the new future museum of The Asia Society.

This shift from private to public venue accompanied a broadening of the scope of the collection by many new acquisitions. A representative but excellent presentation of the art from various Asiatic cultures and periods is particularly significant for a museum operated by an Asia society. A rush to completeness could be disastrous, but the measured and thoughtful expansion of the collection visible in this second showing should dispel any doubts about the qualitative level.

A second problem, consciously studied by Mr. and Mrs. Rockefeller, is one of controlling the size of the collection so as to fulfill its goal of providing both enjoyment and elucidation within the relatively small scale of a specialized museum affiliated with a multi-purpose institution which is dedicated to the understanding of Asia and its relationship to our own culture. One thinks particularly of the small, privately founded public museums of Japan such as the Gotoh or Hatakeyama galleries in Tokyo, the Atami Museum, the Hakone Museum, or the Yamato Bunkakan near Nara, where limited numbers of superb Japanese and Chinese objects can be seen in intimate environments, and within a reasonable compass of time. Large quantities and vast spaces have their uses, but so do their opposites. After too often hearing grandiose orchestral productions involving over a hundred instruments, one can turn with a lightened soul and heightened consciousness to a string quartet. Plurality in types of museums is a positive virtue and this country needs at least a few more non-monumental art museums—particularly for the enjoyment and study of the often quiet and reserved images and forms of Far Eastern art.

Yet another responsibility, the publication and public availability of the collection, is served by this second exhibition and its summary but fully illustrated catalog. We hope that the publication for the first time of thirty-six of these seventy objects will be of interest and use to students and experts in the field. A brief resumé (mentioning only a selection of the selection) here will attempt to indicate the categories that have been strengthened and the areas newly represented in the collection.

The Standing Buddha (No. 1) is now the finest and most important of a group of three metal images of the classical age of Indian Buddhist art—the Gupta period; the others were shown in the 1970 exhibition. The Kashmiri Padmapani (No. 4), the Nepalese Indra (No. 7), and the South Indian Shiva (No. 10), are noteworthy additions to other metal images of the same origin shown previously. All share, in their regional and periodic ways, the taut elegance of Indian metal sculpture of the Medieval period.

The Mon stone Buddha (No. 14) is related to other stone and, particularly, metal images of this initial and most creative period of Buddhist art in Thailand; while the Cambodian bronze (No. 17) joins other smaller examples of the same date and origin.

Chinese porcelains of the Ming and Ch'ing periods, already well represented in the collection, have been further reinforced by outstanding specimens of varying shapes and decor (Nos. 33-37, 43, 44). Japanese wood sculpture (Nos. 48-51), and polychromed porcelains (Nos. 61-66), are fine additions to those shown in 1970.

But even more extraordinary are the new dimensions added to the collection by certain important acquisitions, most particularly in the arts of China, Korea, and Japan. The Han dynasty gilt bronze basin (No. 20) is a well known masterpiece, one of the finest products from the end of the bronze age in China; and with it, the two other gilded metal pieces (Nos. 21, 22), give a remarkably fine and complete idea of ways in which this particular technique was used in the rendering of complex and fascinating representational subject matter.

The Sung stonewares (Nos. 26-30) greatly enlarge the representation of these classic wares,

which were, hitherto, overshadowed by the Ming and Ch'ing porcelains in the collection. From the viewpoints of both rarity and quality, the underglaze red jar of the fourteenth century (No. 32) is one of the most remarkable ceramics in the collection. It is also the first early ware in this technique, invented in the Yüan dynasty, to have been acquired by these collectors.

Jade and lacquer are newly represented in the collection by the two jade animals (Nos. 38, 39), the lacquered wood horse (No. 40), and the famous cinnabar lacquer tray (No. 41), which complement the other objects, in different media and techniques, of the Ming dynasty. The end of that period was noteworthy in painting—particularly in the work of the so-called Individualists. The first Chinese painting to be included in the collection is shown here for the first time, a landscape by Shih-ch'i (K'un-ts'an) (No. 42).

In Japanese art, the Jomon figure (No. 45) and the Haniwa warrior (No. 46) are the first of these early ceramic sculptures to be represented. The most outstanding work from Japan is surely the Tempyo box cover of lacquered leather (No. 47), one of the very few works of decorative art of the Shoso-in type available for study in a Western collection. The subtle differences between Chinese and Japanese versions of this heidatsu technique (gold and silver inlay in lacquer) can be seen by comparing the cover with the small but exquisite Chinese mirror (No. 24) of the T'ang dynasty.

Japanese monochrome ink painting of the Muromachi (Ashikaga) period can now be seen in three succeeding phases—the early and formative work of the early fifteenth century (No. 54); the developed technique of one aspect of ink painting, flung ink (haboku), in a long scroll by Sesson (No. 55); and the formalization of the monochrome tradition at the end of the sixteenth century in the style of Kano Motonobu and his circle (No. 56).

Four woodblock prints reveal the bold designs of four great masters, Utamaro, Shunei, Sharaku, and Choki, in impressions marvelously preserved and skillfully executed (Nos. 57-60). There is no intention here of creating a collection of Japanese prints, but rather of showing a few fine examples of this wonderfully inventive aspect of the creative art of Japan. Finally, we come to the enamelled jar by Ninsei (No. 67), one of the very few of his well known decorated

ceramics to leave Japan. The artful boldness of form and composition provides an aristocratic counterpoint to the variation of the Japanese decorative style to be seen in the four woodblock prints.

Korean art was not shown in the first exhibition and the ceramics seen here (Nos. 68-70) add a much needed sampling of this particularly creative aspect of Korea's artistic production.

I am much indebted to my colleague Wai-kam Ho for translations and assistance on Nos. 42 and 54; and to Miss Bertha Saunders for her generous cooperation in numerous and varied problems involved in her care of the collection. The Asia Society has again given every assistance possible, for which I am most grateful. The faults to be found are, however, my responsibility, including the brevity of the entries—many of those devoted to the ceramics are indebted to the previous spade-work of Sotheby's and Christie's cataloguers. However, it was not our intention to produce more than a useful summary catalogue. The emphasis is on making the new selection available through illustration. Finally, I am much beholden to Mr. and Mrs. Rockefeller for their sympathetic cooperation in making the exhibition possible.

Sherman E. Lee
Director, The Cleveland Museum of Art

The Art of Greater India

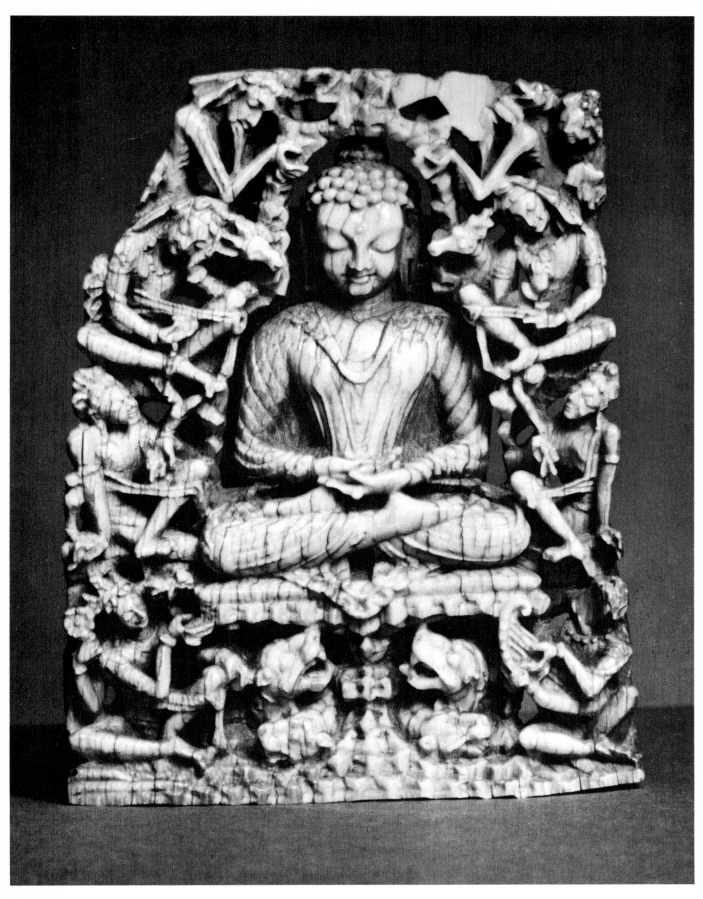

2. *Kneeling Figure.* Afghanistan; fourth–fifth century. Stucco; H. 12⅞ in.

3. *Adoration of the Buddha.* Kashmir; eighth–ninth century. Ivory; H. 3⅞ in. (*opposite*)

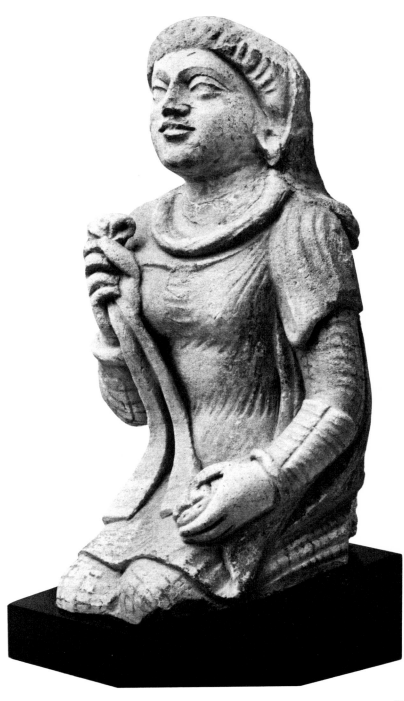

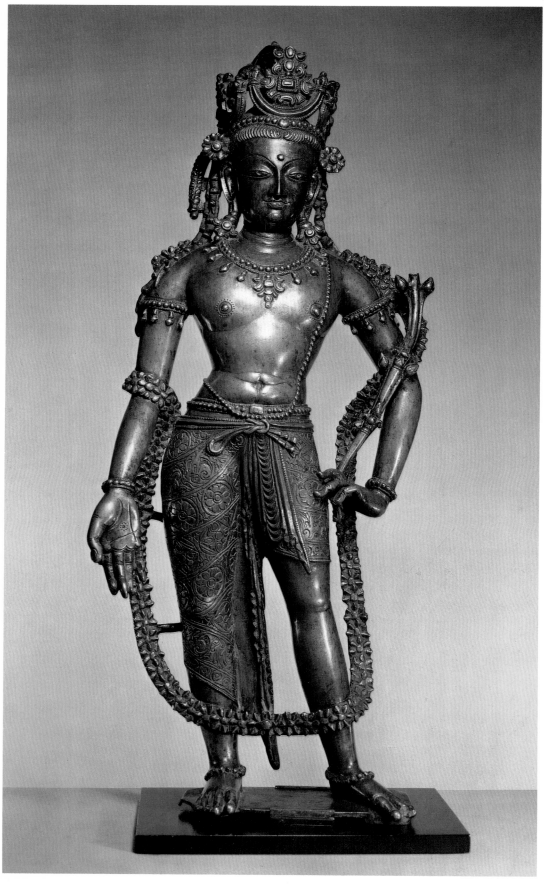

4. *Padmapani*. Kashmir; ninth century. Brass with copper and silver (?) inlays; H. 27 in.

7. *Indra*. Nepal; twelfth-thirteenth century. Gilt copper with inlays of garnet, turquoise and lapis lazuli; H. 10 in. (*opposite*)

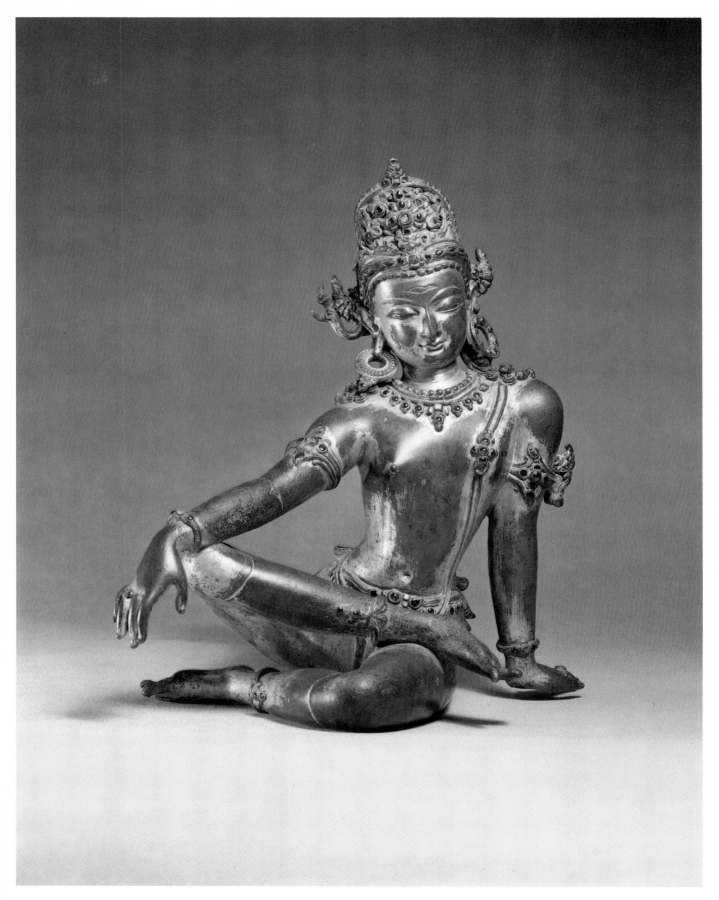

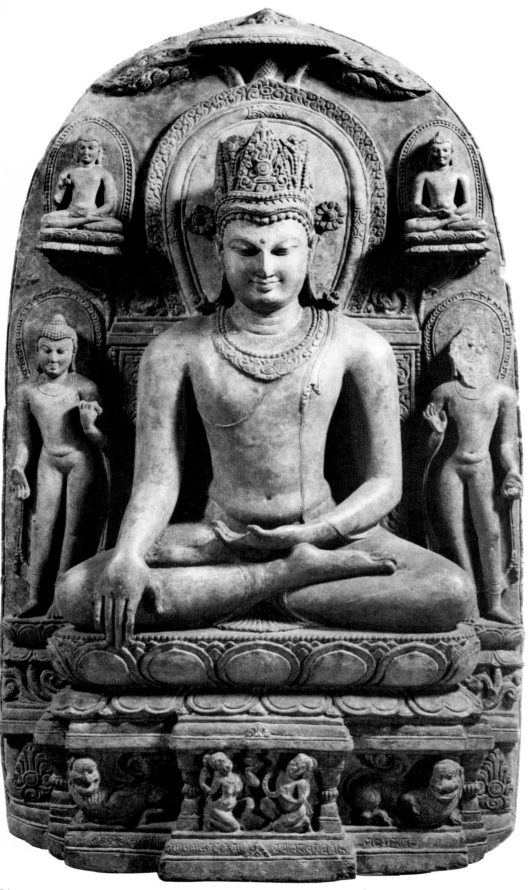

5. *Seated Crowned Buddha.*
India; Pala Period,
tenth century.
Gray chlorite; H. 27¾ in.

6. *Navatmaka Heruka* (?).
India, Bengal; Sena
dynasty, twelfth century.
Black chlorite; H. 19 in.

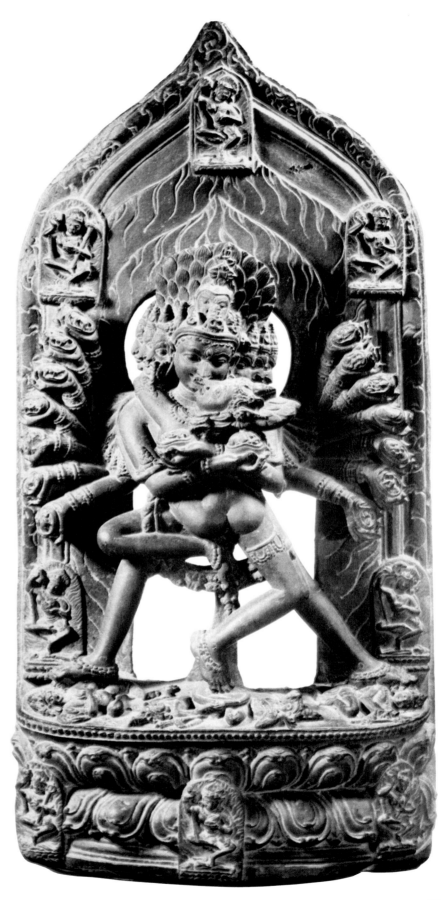

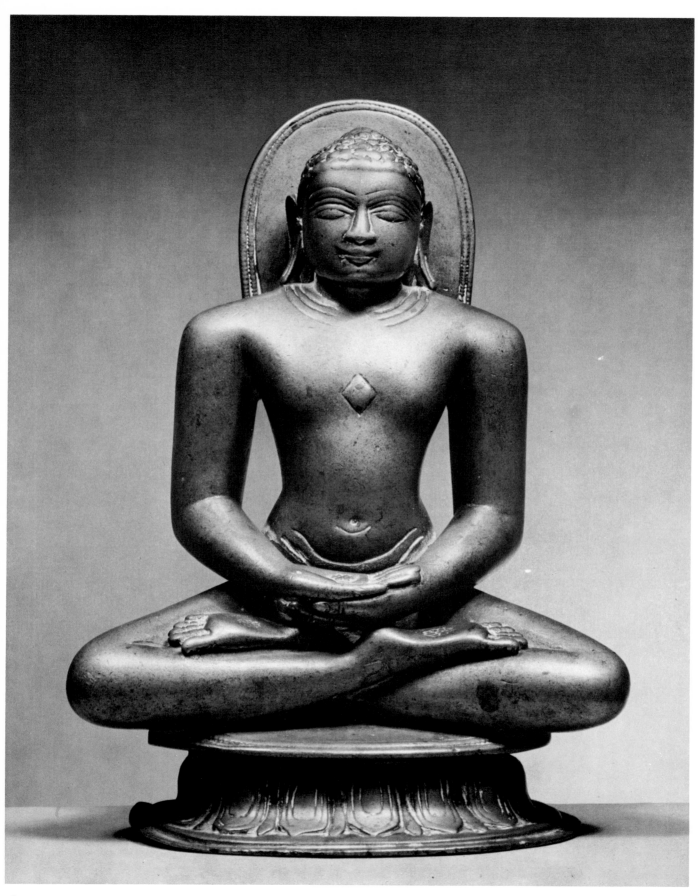

8. *Ten-armed Ganesha.*
Central India; eighth
century.
Dark brown sandstone;
H. 49 ½ in.

9. *Seated Tirthankara.*
Central India;
seventh–eighth century.
Bronze; H. 11 ¼ in. (*opposite*)

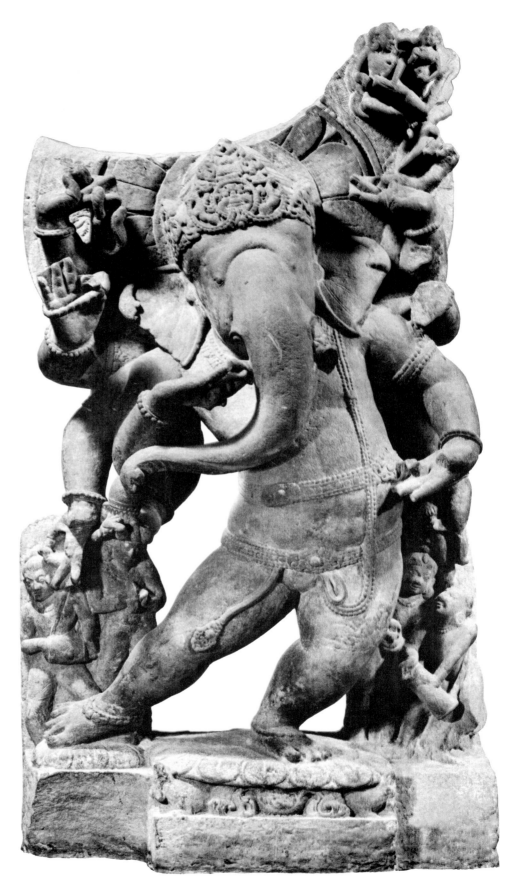

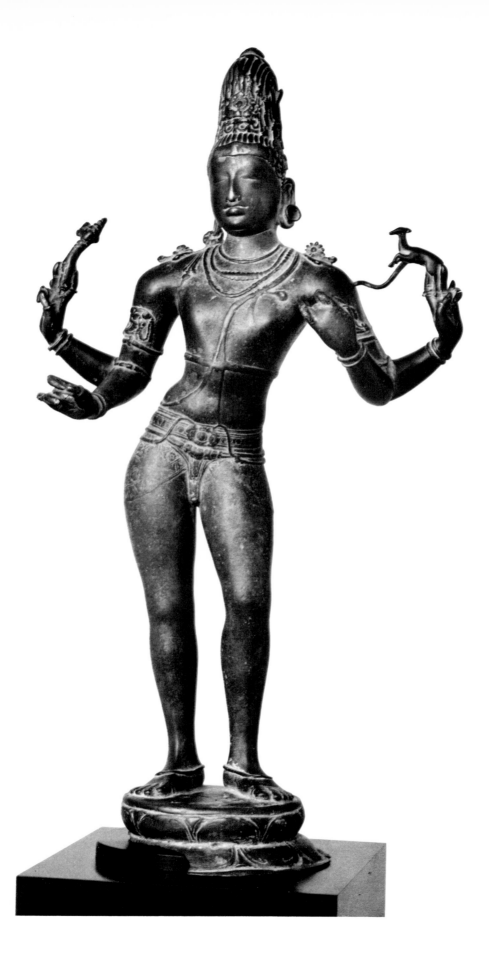

10. *Standing Shiva*. South
India; early Chola period,
tenth century.
Copper; H. 27¾ in.

11. *Nataraja: Shiva as Lord of the Dance*. South India; Chola period, twelfth century.
Copper; H. 29 ½ in.

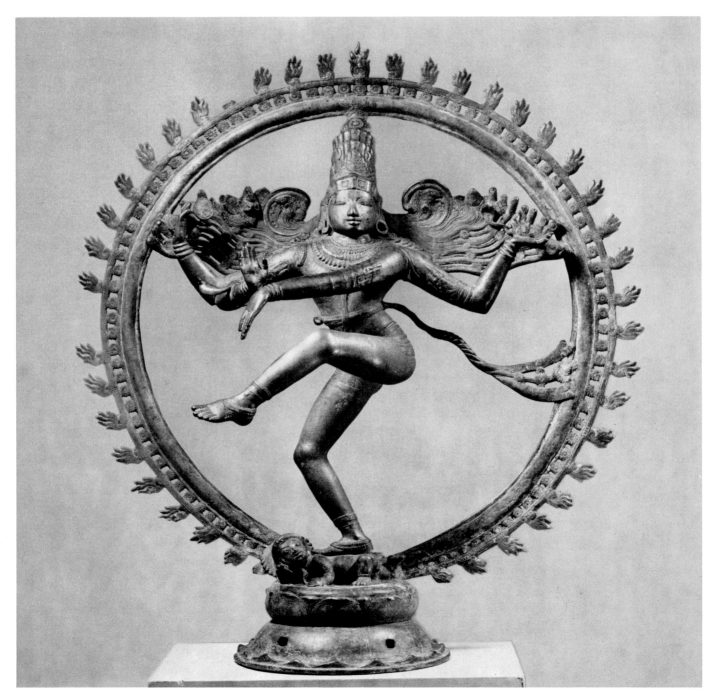

1. Standing Buddha
India; Gupta period, 320–647
Bronze; H. 27 in. *frontispiece*

The right hand of the Buddha is in the *abhaya* (fear not) *mudra;* the left catches the corner of the monastic robe, which is represented by string-like drapery in the manner associated with the Mathura school of the Gupta period. The large size and classic perfection of this piece make it one of the most important of Gupta bronze images. The collection also contains a standing and a seated bronze Buddha of the Gupta period, with plain drapery of the Sarnath type (see *Asian Art: Selections from the Collection of Mr. and Mrs. John D. Rockefeller 3rd* [New York: The Asia Society, 1970], pls. 2, 3).

Published: *Marg*, vol. IV, no. 4 (1950), p. 11, fig. 3.

Formerly S. K. Bhedwar Collection.

2. Kneeling Figure
Afghanistan; fourth-fifth century
Stucco; H. 12⅞ in.

This kneeling figure of a female devotee, with traces of red pigment on the surface of the dress, is probably from Hadda in Afghanistan. She holds a sash in the right hand, a piece of fruit in the left. The check-patterned skirt and the facial type show the Iranian influence typical of many of the Hadda stuccos. Reasonably complete figures such as this one are comparatively rare. The largest groups of these stuccos are in the Kabul Museum and in the Musée Guimet (see B. Rowland, *Ancient Art from Afghanistan* [New York: The Asia Society, 1966], pp. 72–91).

Formerly J. R. Belmont Collection.

3. Adoration of the Buddha
Kashmir; eighth-ninth century
Ivory; H. 3⅞ in.

The youthful Buddha figure, clothed in a string-drapery garment of the Udayana type, is seated in the lotus pose on a double vajra (?) supported by two lions. The Buddha's hands are placed in the *mudra* of meditation (*dhyani*). He is flanked by six Bodhisattvas, one of whom is playing a harp. Forming an arch above the Buddha's head are two bearded *rishis* (the head of one is missing) and below them are the heads of two deer, alluding perhaps to the Buddha's sermon in the Deer Park. The head of an *apsaras* is seen at the upper right corner; the corresponding one on the left is now missing.

Similar plaques are in The Cleveland Museum of Art; British Museum, London; Prince of Wales Museum, Bombay. See F. M. Asher, "Buddhist Ivories from Kashmir," *Oriental Art* (Winter, 1972), pp. 367–73; M. Beach, "Two Indian Ivories Newly Acquired," *Bulletin of The Museum of Fine Arts, Boston*, vol. LXII (1964), pp. 95–101; and M. Chandra, "Ancient Indian Ivories," *Prince of Wales Museum Bulletin*, no. 6 (1957–59), pls. 6–10. These others show traces of gilding and polychrome, missing from this plaque probably due to cleaning.

4. Padmapani
Kashmir; ninth century
Brass with copper and silver (?) inlays; H. 27 in.

The crowned Bodhisattva is draped with a garland of flowers and holds a long-stemmed lotus in his left hand. Because of its unusually large size and its voluptuous modeling, this figure can be considered one of the finest of Kashmiri metal sculptures.

5. Seated Crowned Buddha
India; Pala Period, tenth century
Gray chlorite; H. 27¾ in.

The central Buddha figure, with his hands in the *bhumisparsa* (earth-touching) *mudra*, is seated cross-legged on a lotus throne beneath a parasol and two leaves of the bodhi tree. He is flanked by two standing Buddhas and above them is another pair of small Buddha figures seated on lotuses; one is making the gesture for "fear not," the other holding a small bowl or reliquary and meditating. The throne has a lion support on either side, and in the center a panel with two kneeling worshippers. A dedicatory inscription, invoking the power of the Buddha, runs around the front of the base. The "metallic" appearance of the carved details and the linear character of the features indicate that the piece belongs to the late Pala period.

6. Navatmaka Heruka (?)
India, Bengal; Sena dynasty, twelfth century
Black chlorite; H. 19 in.

This sculpture portrays a Tantric manifestation of the Buddha dancing in union with his partner, Nairatma (Without Selfhood). The advanced, highly developed Tantrism of the iconography and the extremely "metallic" character of the precise carving confirm a date after the Pala dynasty. For the iconography, see S. Kramrisch, *The Art of Nepal* (New York: The Asia Society, 1964), p. 134, no. 29.

7. Indra
Nepal; twelfth-thirteenth century
Gilt copper with inlays of garnet, turquoise, and
 lapis lazuli; H. 10 in. *illus. p. 13*

This figure of Indra, the Hindu Lord of gods, is clearly related, though more informal in pose, to an image in the Seattle Art Museum (see Kramrisch, *The Art of Nepal*, no. 18). According to Dr. Kramrisch, the best that the Newari sculptor had to give often went into the making of images of this god, who plays an important part in the legends, life, and art of Nepal.

8. Ten-armed Ganesha
Central India; eighth century
Dark brown sandstone; H. 49½ in.

The relatively elongated proportions of the figure and the elaborate crown, with its mask and garlands of pearls, suggest an early date in the sequence of medieval art styles. The "flavor" of this strong sculpture seems related to carvings in the cave temple of Ellora and other sites of the eighth century. This is certainly one of the earliest of Ganesha images.

9. Seated Tirthankara

Central India; seventh-eighth century
Bronze; H. 11 ¼ in.

The nude Jain figure has the distinctive sacred lozenge mark on the chest. The head is framed by a halo with a double-beaded border; the base is in the form of an oblate inverted lotus. Seated images of this deity in bronze are far less common than standing ones, and the proportions of this piece are particularly strong and bold.

10. Standing Shiva

South India; early Chola period, tenth century
Copper; H. 27¾ in.

This figure is probably a representation of Shiva Vinadhara (Holding a Lute). The slender, elegant proportions, the details of the headdress, armlets, and girdle, the gracious facial type—all point to a date in the Chola period. The closest parallel to this image is the Vinadhara in the Tanjore Art Gallery (see C. Sivaramamurti, *South Indian Bronzes* [New Delhi, 1963], pl. 31a; slightly less close, but still germane, is Pl. 32a, a Kiratamurti in the same collection).

11. Nataraja: Shiva as Lord of the Dance

South India; Chola period, twelfth century
Copper; H. 29 ½ in.

The vegetal scrolls in Shiva's flying hair are unusual, but in other respects this image conforms to the fully developed Chola representation of Nataraja, the most famous of all South Indian icons. The wide jaws and tight-lipped smile are characteristic of many images produced during or just after the time of Raja Raja I (985–1018), including the image of ca. A.D. 1000 at the Brihadeswara Temple, Tanjore. Particularly striking are the supple modeling and rhythmic unity of this work. The perfectly circular mandala and the small scale of the details indicate a date in the late Chola period. The image is complete except for two flames missing from the edge of the mandala.

The Art of Southeast Asia

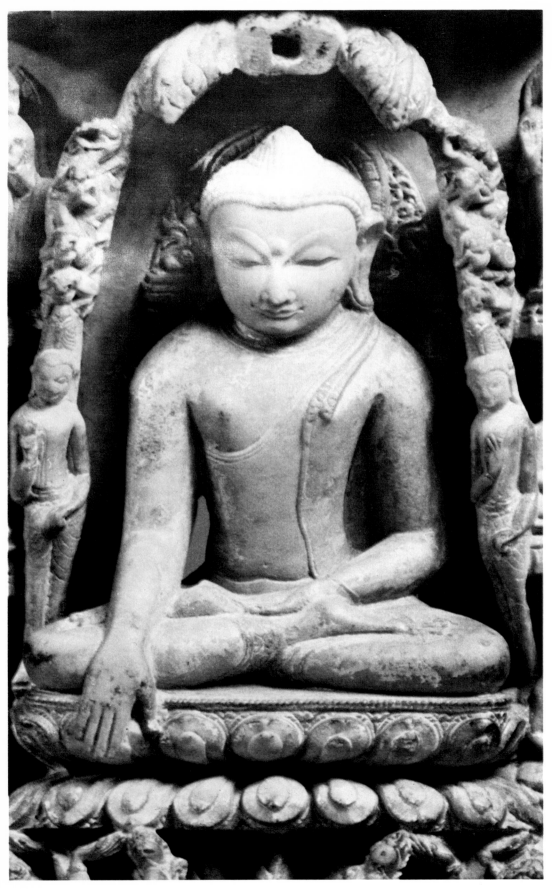

13. *Buddhist Stele*. Burma;
twelfth century.
Fine-grained sandstone with
remains of gold leaf;
H. 7¾ in.

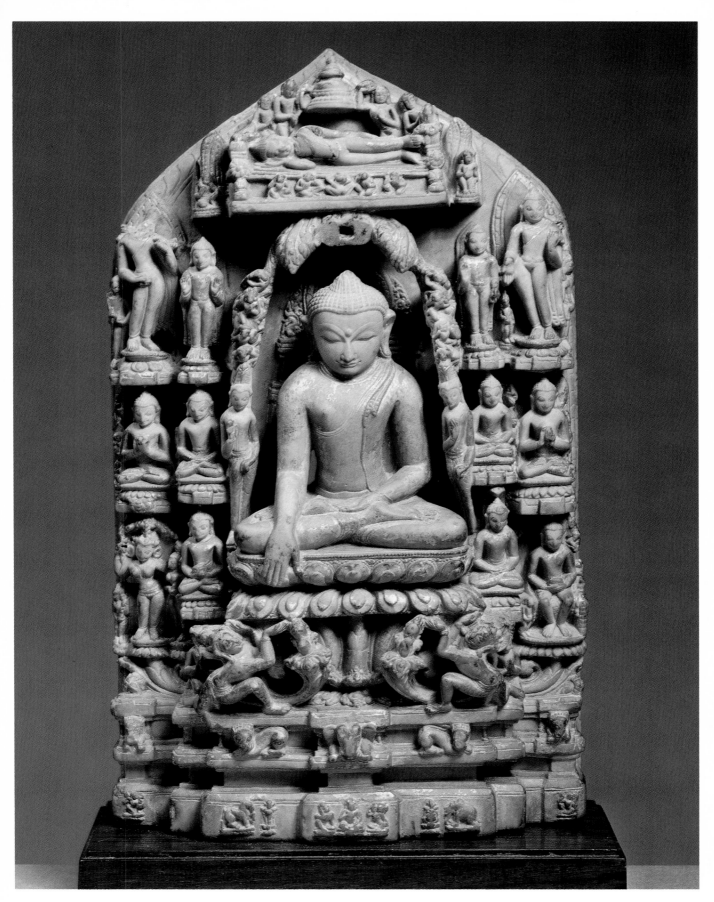

15. *Stele With Buddha and Two Attendants or Bodhisattvas* (?). Siam; Mon-Dvaravati style, eighth century. Gray-green sandstone; H. 17 in.

16. *Standing Uma*. Cambodia; pre-Angkor period, late seventh century. Fine gray-green sandstone; H. 16 ½ in. *(opposite)*

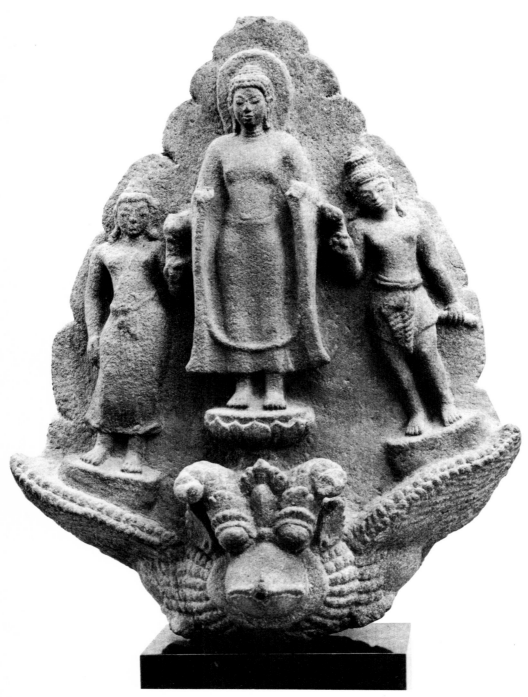

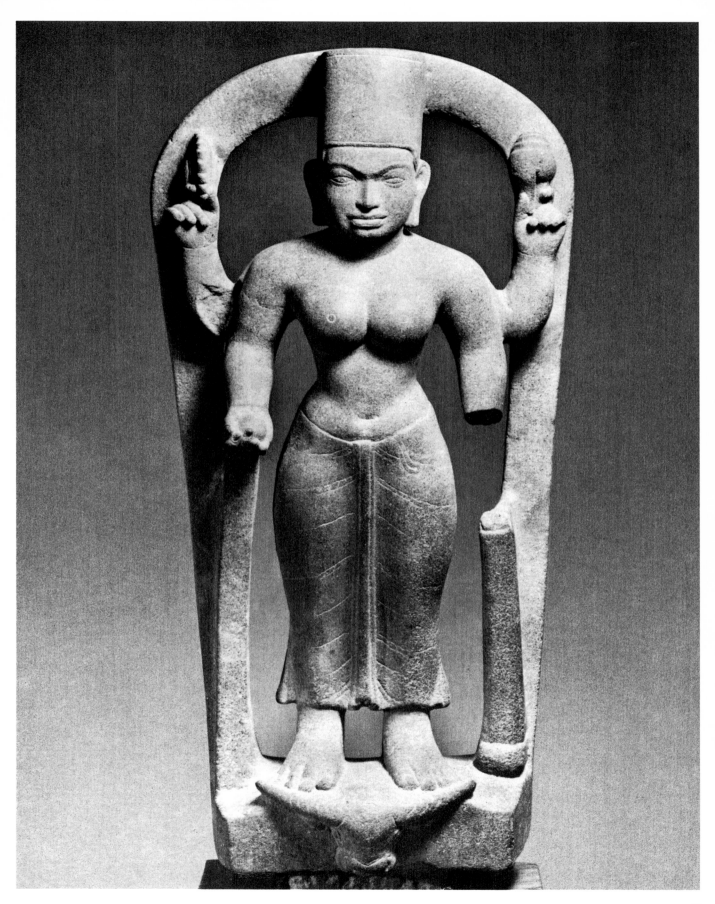

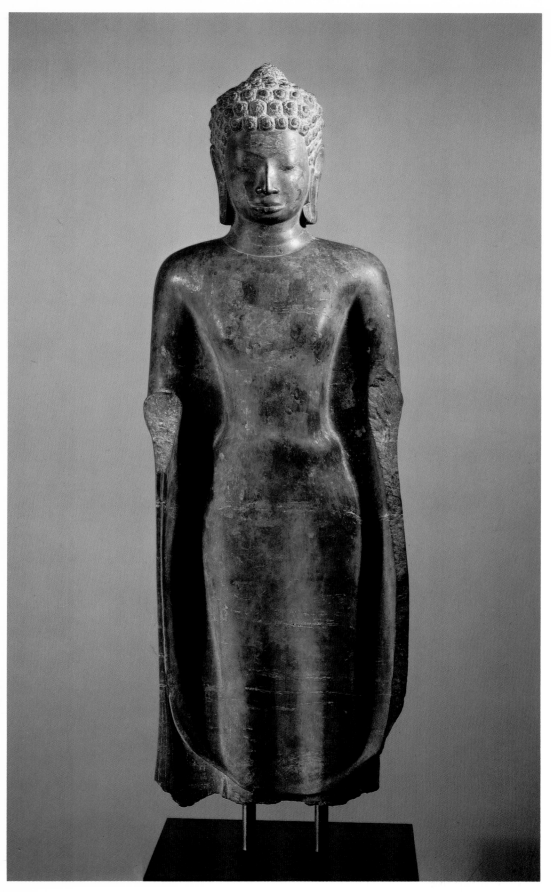

14. *Standing Buddha.* Siam;
Mon-Dvaravati style,
eighth century.
Limestone; H. 36½ in.

12. *Seated Buddha*. Burma;
eleventh century.
Brass and copper; H. 5⅝ in.

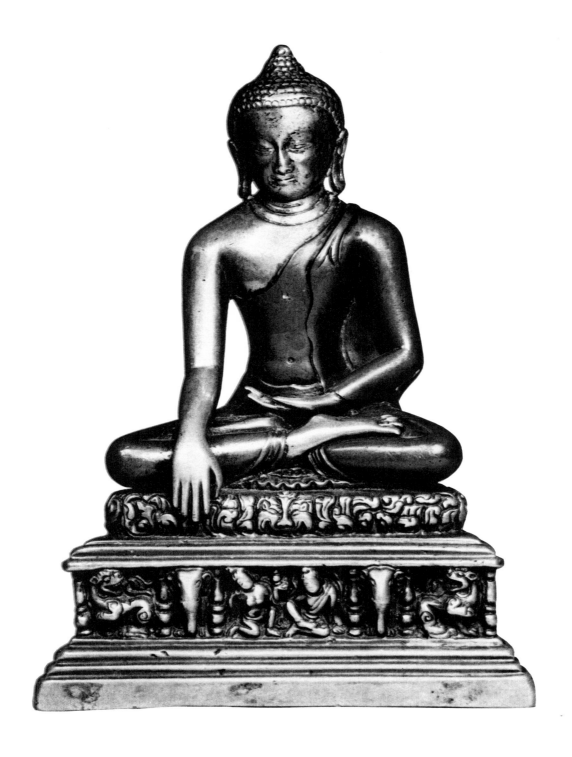

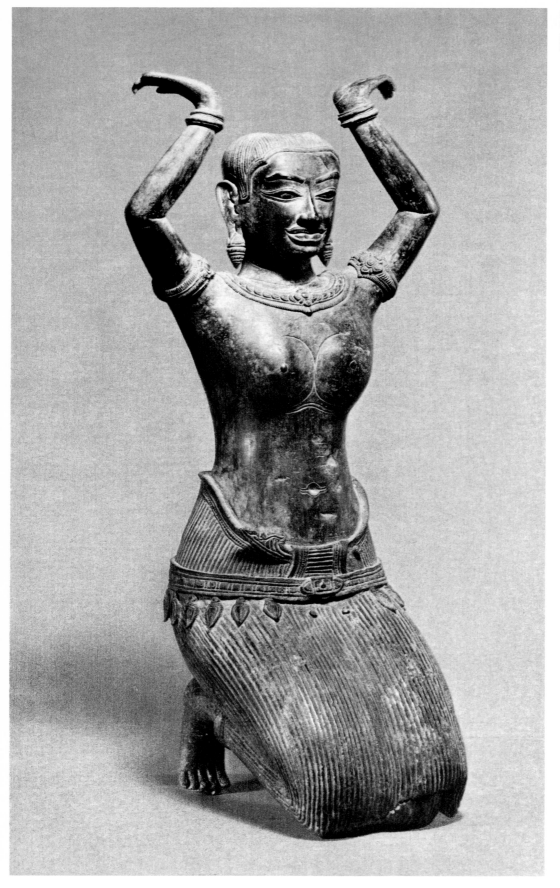

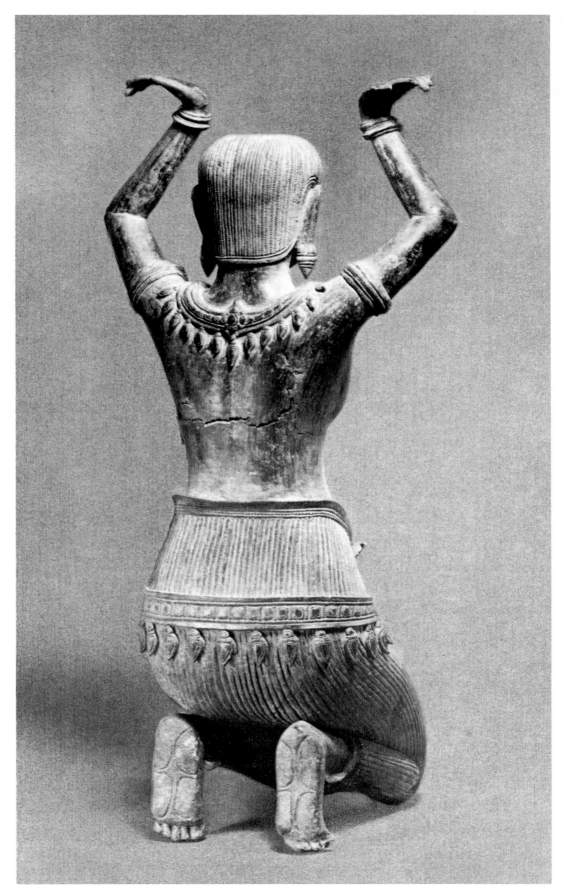

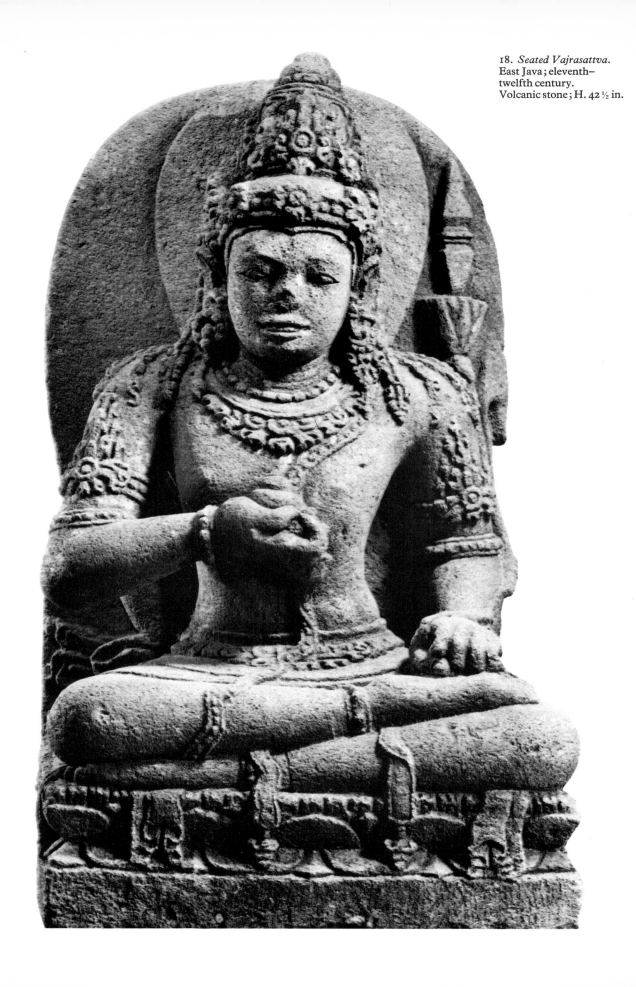

18. *Seated Vajrasattva.*
East Java; eleventh–
twelfth century.
Volcanic stone; H. 42 ½ in.

12. Seated Buddha

Burma; eleventh century
Brass and copper; H. 5⅝ in. *illus. p. 29*

The Buddha, shown in the *bhumisparsa mudra*, is seated on a semicircular, tiered throne which is covered with a lion's skin. The throne is supported by a pair of lions and two figures, one male, one female; they refer to the Temptation of Buddha by Mara. Both the base and the exposed flesh are of brass while the garments are executed in copper. For a comparable figure in the National Museum of India, New Delhi, see P. Pal, "The Story of a Wandering Bronze Buddha—and Two Examples from American Collections," *Connoisseur* (Nov. 1972), nos. 1 and 2.

13. Buddhist Stele

Burma; twelfth century
Fine-grained sandstone with remains of gold leaf; H. 7¾ in.

Shakyamuni is seated at the center of the stele with his right hand in the *bhumisparsa mudra*. The stele shows eight events in the life of the Buddha. The area behind the central figure is hollowed out and a Tibetan sign, *om* (generally considered to be the sound-symbol of the Supreme One), is carved on the back. The style and iconography are derived from Bengali sculpture of the Pala period. (cf. No. 5). This miniature stele is closely related to smaller examples in The Cleveland Museum of Art and in the George Bickford Collection, Cleveland. See also G. H. Luce, *Old Burma-Early Pagan* (New York, 1970), vol. 2, pp. 171–75, and vol. 3, pls. 400–405.

14. Standing Buddha

Siam; Mon-Dvaravati style, eighth century
Limestone; H. 36½ in. *illus. p. 28*

Stylistically, the symmetrical disposition of the body and the facial type of this very individual sculpture fall into Dupont's type C (see P. Dupont, *L'Archéologie Mone de Dvaravati* [Paris, 1959], vol. I, pp. 188ff.; and vol. II, pls. 101–103). Related pieces in the Nelson-Atkins Gallery of Art, Kansas City, Mo., and the Seattle Art Museum seem slightly later in date, particularly in view of the markedly increased use of linear details in the faces and the smaller size of the curls (see B. Rowland, *The Evolution of the Buddha Image* [New York: The Asia Society, 1963], pl. 27 and B. Rowland, *The Art and Architecture of India* [Baltimore, 1959], pl. 154). The somewhat disturbingly animal-like face of this image is particularly unusual.

15. Stele with Buddha and Two Attendants or Bodhisattvas (?)

Siam; Mon-Dvaravati style, eighth century
Gray-green sandstone; H. 17 in.

This stele is similar to a few other rare examples; the finest of those to have been published thus far is in the National Museum, Bangkok (see Bowie [ed.] *The Sculpture of Thailand* [New York: The Asia Society, 1972], no. 25). The iconography of the present example is comparable to that of the Bangkok stele. The deity on the Buddha's right may be Padmapani, since he seems to hold a lotus in his left hand; the figure to the Buddha's left may well be Maitreya, if one can judge from the costume which clearly resembles that of a pre-Angkor bronze Maitreya in The Cleveland Museum of Art. Garuda supports the figures. Another stele of this type is in the S. Millikin Collection, Cleveland (see G. Coedès, "Une Exposition de Sculptures ...," *Artibus Asiae*, vol. I (1926), illus. p. 193).

16. Standing Uma

Cambodia; pre-Angkor period, late seventh century
Fine gray-green sandstone; H. 16½ in.

The four-armed goddess displays three of the attributes of Vishnu, her consort—the disc, the conch, and the mace. The straight-sided miter, the rigidly balanced and symmetrical composition, and the strong vertical pleat of her garment may be compared to another unusual image published in P. Dupont, *La Statuaire preangkorienne* (Ascona, 1955), pp. 165, 166 and pl. 37a, and identified as being from Kompong Khleang. Dupont considers this latter image as related to the Sambor style and anticipating that of Prasat Andet, that is, after the first half of the seventh century but before the eighth. The relative completeness of this image and its modeling, powerful and smooth despite its scale, make the sculpture an unusual and an aesthetically significant work.

17. Kneeling Woman

Cambodia; first Angkor style, twelfth century
Bronze; H. 18½ in. *illus. p. 30*

While the skirt is reminiscent of Baphuon examples, the face, necklace, and linear stylization of this sculpture recall the earlier style at Angkor which was coincident with the building of Angkor Vat. The figure may be related to a Baphuon style mid-eleventh century bronze figure of a kneeling woman, of about the same size, in the Metropolitan Museum of Art. See also the example at the Musée Albert Sarraut, Phnom Penh, in J. Boisselier, *La Statuaire khmère et son evolution* (Saigon, 1955), pl. 109.

18. Seated Vajrasattva

East Java; eleventh-twelfth century
Volcanic stone; H. 42½ in.

Vajrasattva is seated on an oblong base decorated with lotus petals and seeds. He holds a small covered vessel in the right hand and the stalk of a lotus in the left. Above the lotus blossom a double *vajra* is carved in relief on the larger nimbus. The deity wears necklaces, armlets, several torques, and a sacred thread which passes over the girdle and the right leg. Curled locks interspersed with jewels fall on either side of the head, which is surmounted by a high crown. The protruding teeth indicate the "terrible" aspect of the deity. Behind the head is a small, ovoid nimbus. This monumental sculpture is related stylistically to a group of four miniature Javanese bronzes in the collection, perhaps from Ngandjuk (see *Asian Art: Selections from the Collection ...*, pl. 29, pp. 43, 45).

Far Eastern Art

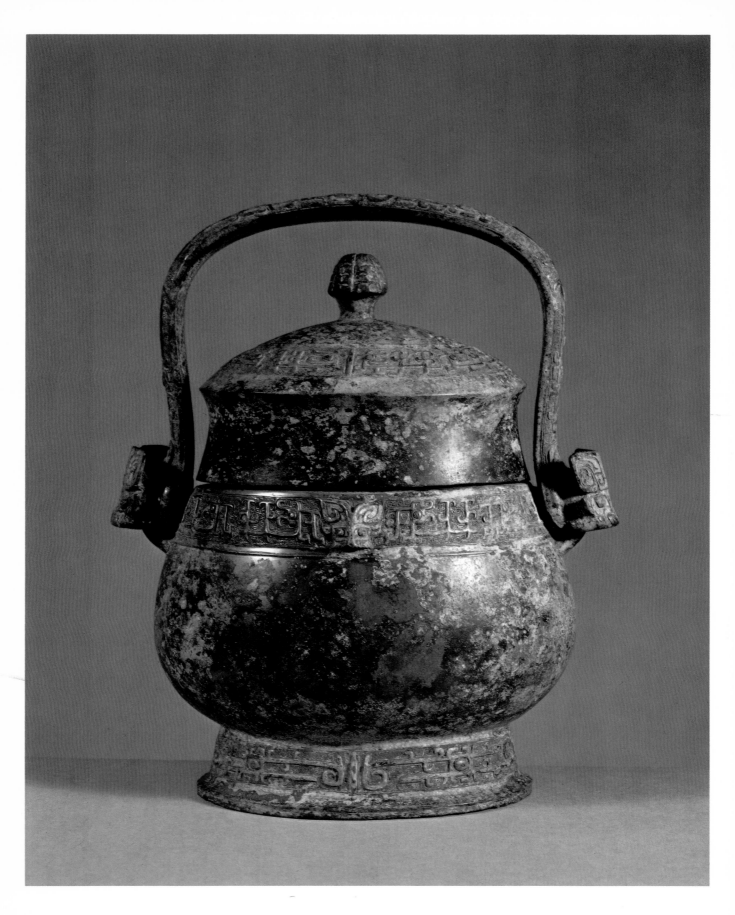

19. *Yu*. China; early Chou
period, ca. 1027 B.C.
Bronze; H. 12¾ in.
(*opposite*)

21. *Po-shan-lu* (*Hill Censer*).
China; Eastern Han
dynasty, 25–220.
Gilt bronze; H. 5½ in.

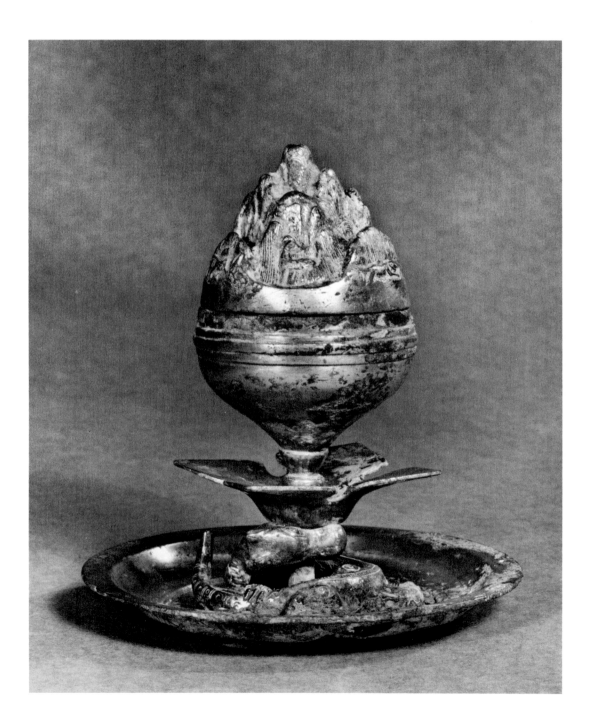

20. *P'an* (*Basin*). China;
Western Han dynasty,
206 B.C.–A.D. 9.
Bronze, engraved and gilded,
with silver inlays;
Diam. 20 in.

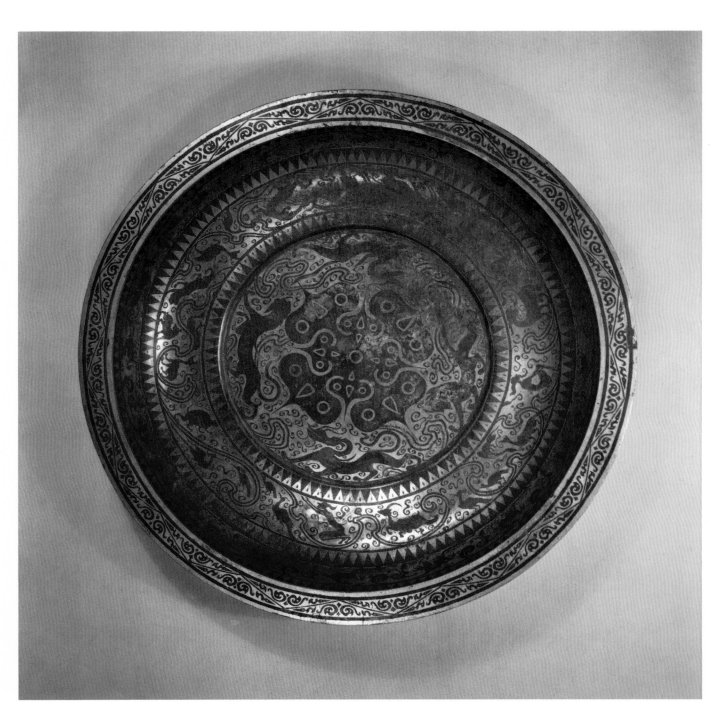

24. *Mirror*. China;
T'ang dynasty, 618–907.
Bronze, with gold and silver
inlays in lacquer (*heidatsu*);
H. 5⅞ in., W. 5⅞ in.

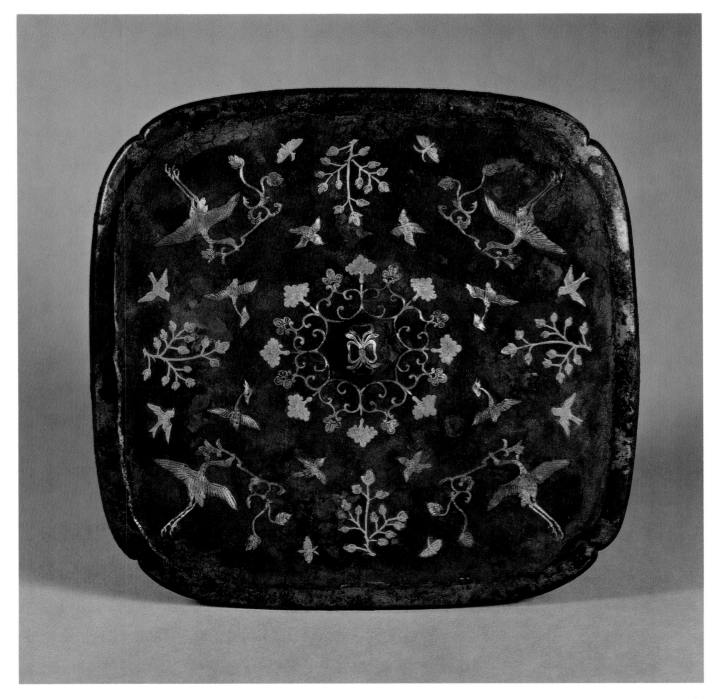

22. *Dish*. China;
sixth century.
Silver gilt with repoussé
design; Diam. 4 15/16 in.

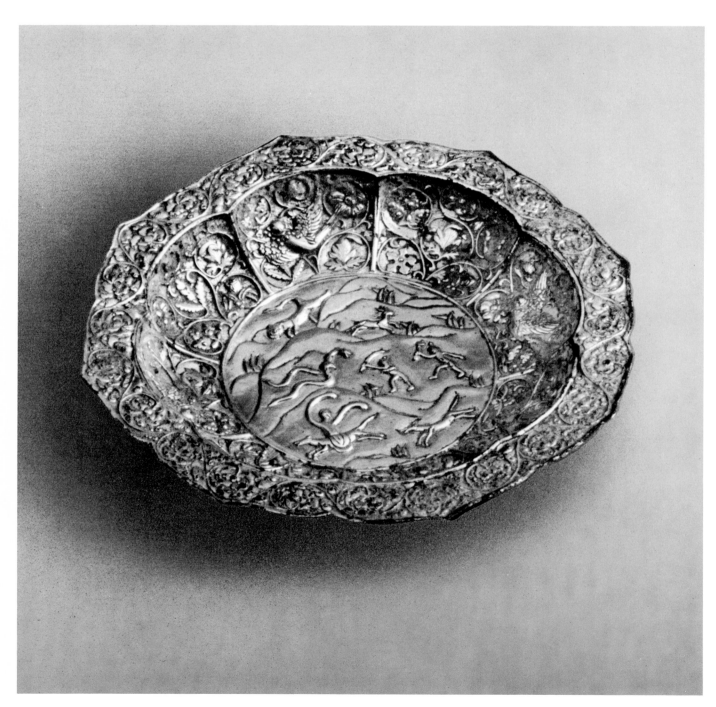

23. *Seated Buddha*. China;
Northern Ch'i dynasty,
dated 551.
Gilt bronze; H. 7 ⅛ in.

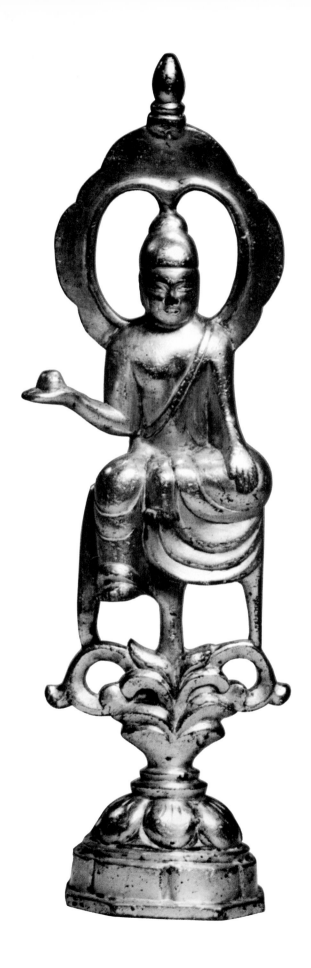

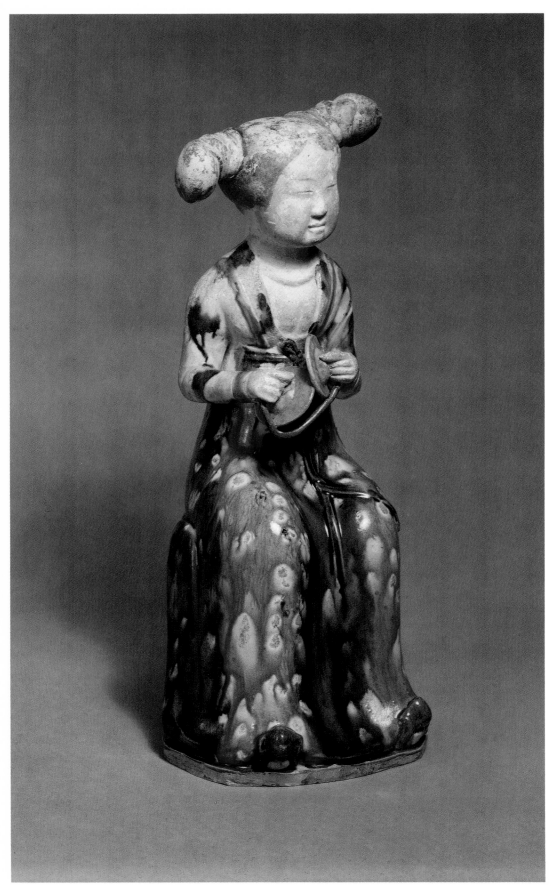

25. *Court Lady With Cymbals.* China; T'ang dynasty, 618–907. Lead-glazed pottery; H. 13 ½ in.

27. *Hsi* (*Brushwasher*).
China; Northern Sung
dynasty, 960–1127.
Chün ware, glazed
stoneware; Diam. 7 ½ in.

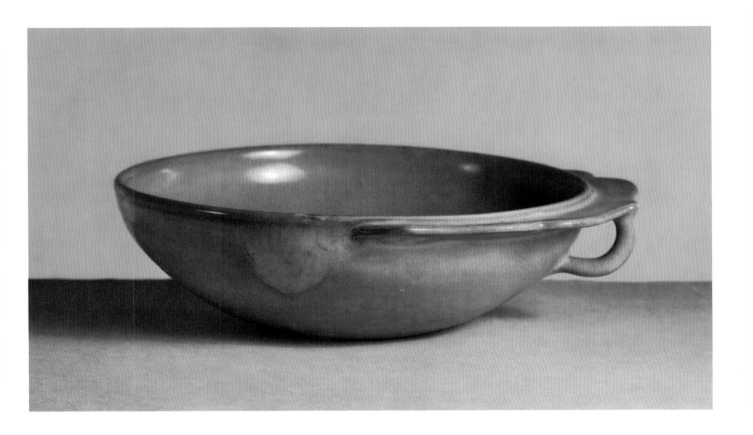

26. *Bowl*. China; dated 1162.
Olive-green glazed stone-
ware; H. 4⅝ in., Diam. 8 in.

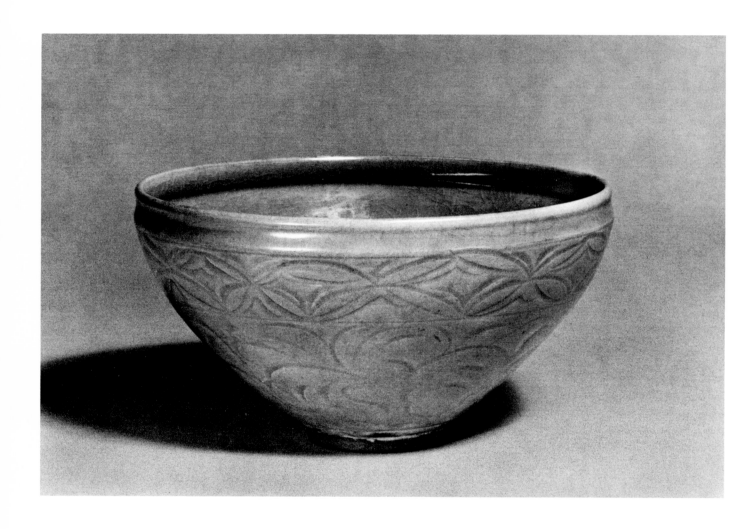

28. *Bowl*. China; Northern
Sung dynasty, 960–1127.
Chün ware, glazed
stoneware; Diam. 3 ½ in.

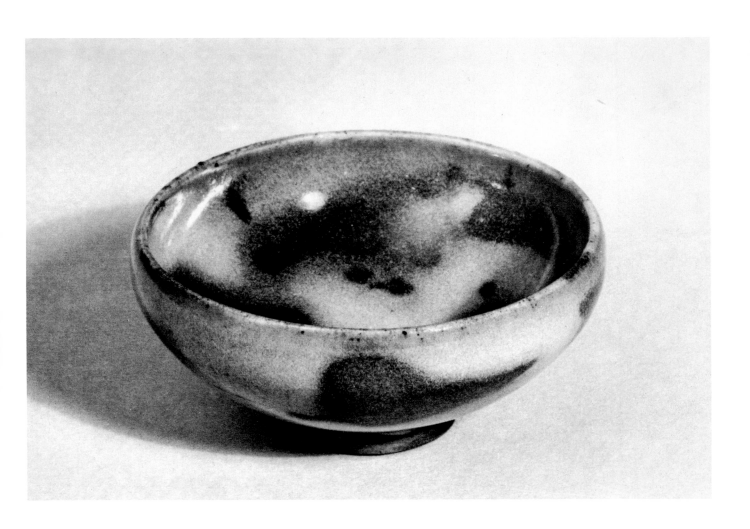

29. *Tea Bowl*. China;
Sung dynasty, 960–1279.
Chien ware, glazed brownish
purple stoneware, with
silver rim; Diam. 4¾ in.

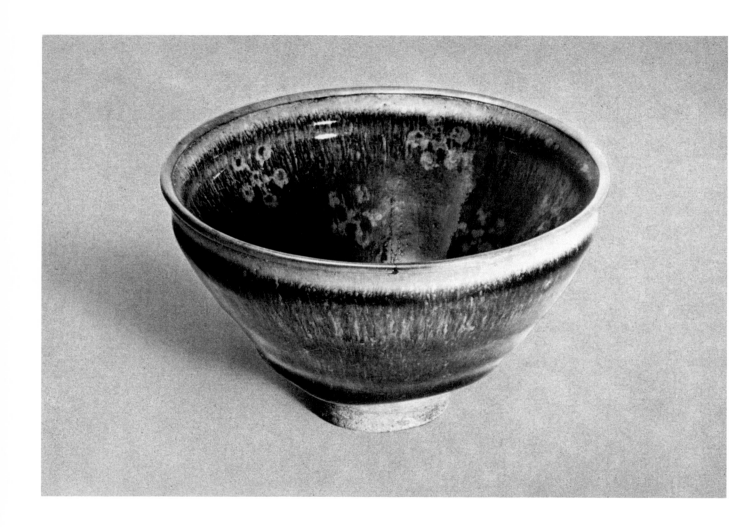

30. *Hsi* (*Brushwasher*).
China; Northern Sung
dynasty, 906–1127.
Honan stoneware with black
"oil-spot" glaze;
Diam. 6 ½ in.

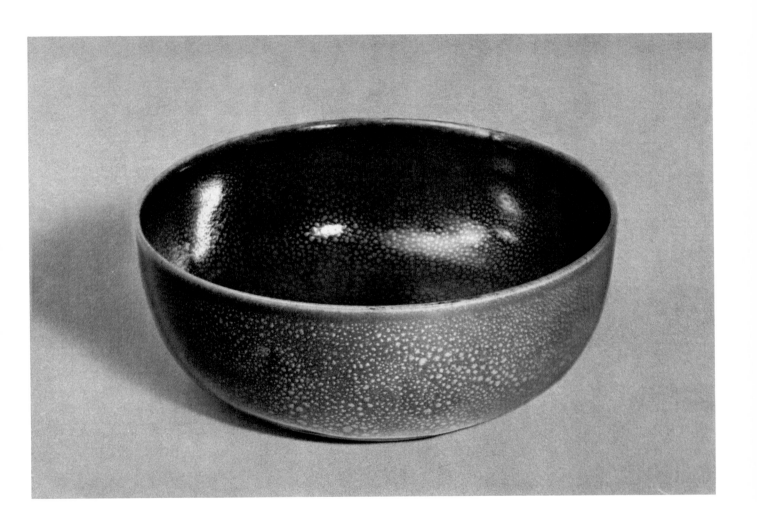

31. *Cha Tou* (*Double Jar*).
China; late T'ang dynasty.
Gray-white porcelain body
with brown-black glaze;
H. 4⅜ in., Diam. 4⅜ in.

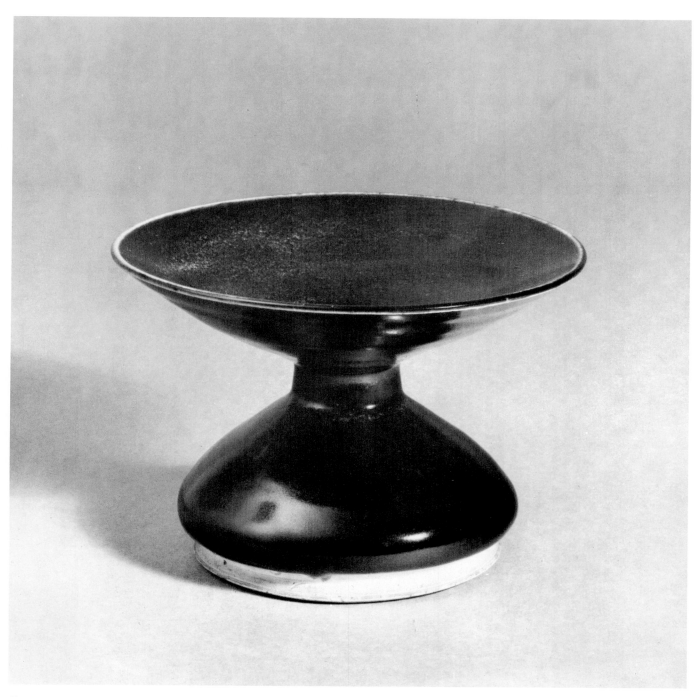

36. *Chi-Hung (Sacrificial Red) Dish*. China; Ming dynasty, second half of the fifteenth century, probably reign of Ch'eng Hua, 1465–1487. Porcelain with underglaze red; Diam. 6⅝ in.

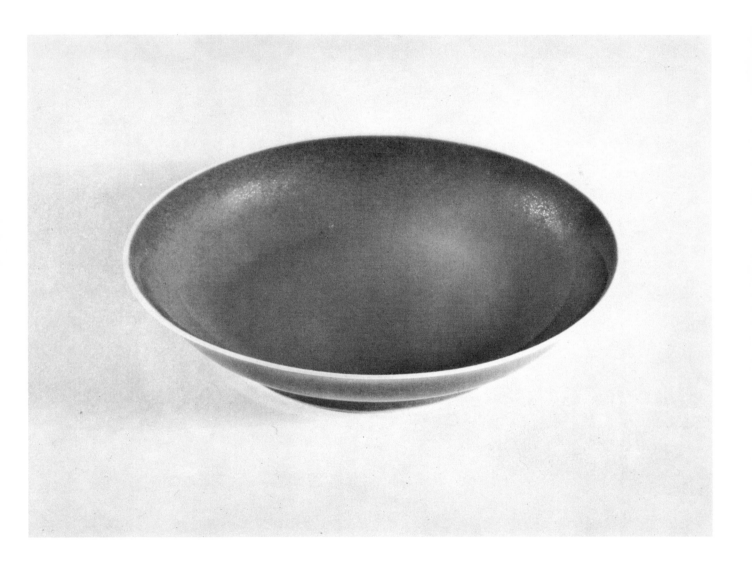

32. *Jar with Decoration of the
"Three Friends."* China;
Yüan dynasty, 1280–1368.
White porcelain with under-
glaze red; H. 20 ½ in.

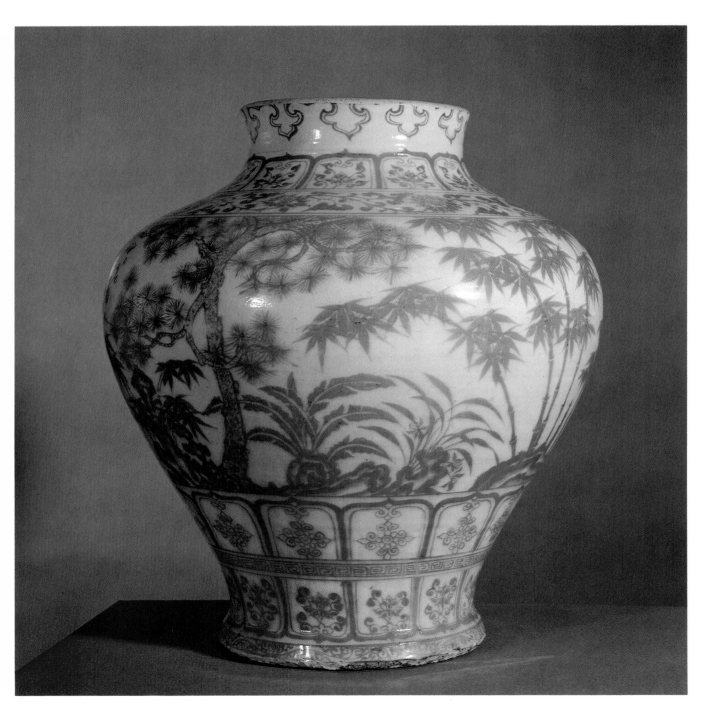

34. *Jar with Peony Decoration.* China; Ming dynasty, fifteenth century, probably reign of Yung Lo, 1403–1424.
Porcelain with decoration in underglaze blue; H. 9⅜ in.

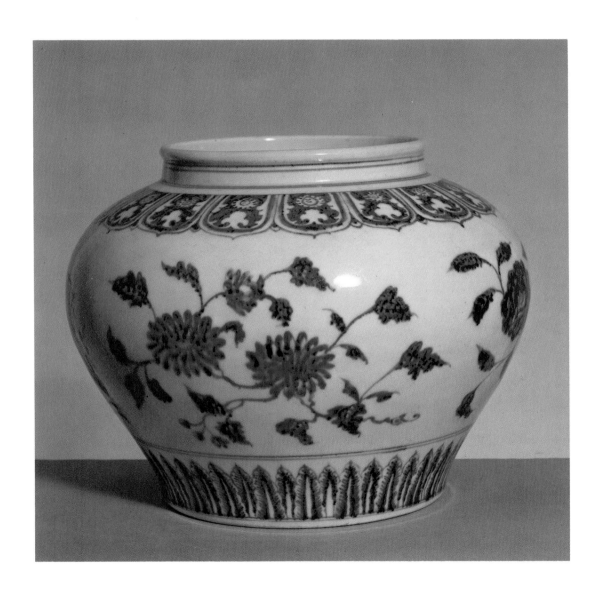

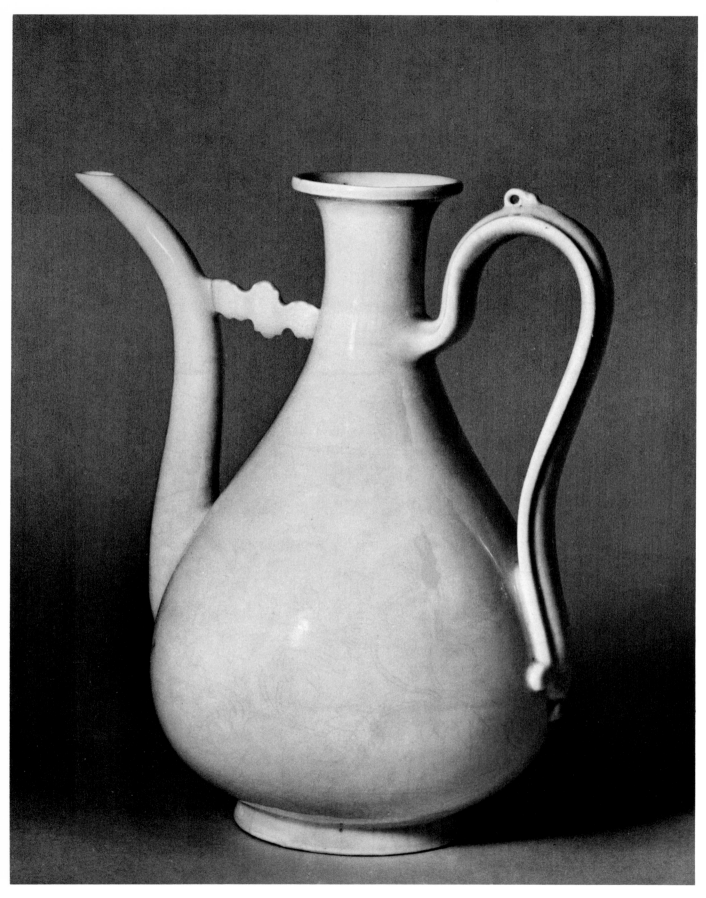

33. *Ewer*. China; Ming
dynasty, reign of Yung Lo,
1403–1424.
Porcelain; H. 13 in. (*opposite*)

35. *Blue and White Dice
Bowl*. China; Ming
dynasty, mark and reign of
Hsüan Te, 1426–1435.
Porcelain; H. 4½ in.,
Diam. 11⅞ in.

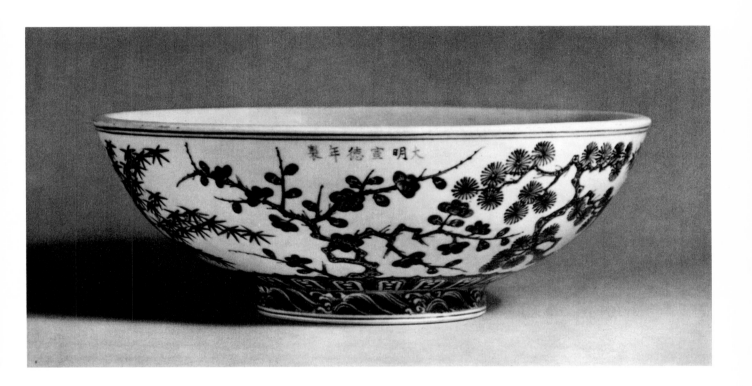

38. *Chimera* (?). China;
Sung to Ming dynasty,
960–1644.
Green-gray jade with brown
fissures; L. 12 in., H. 8 in.

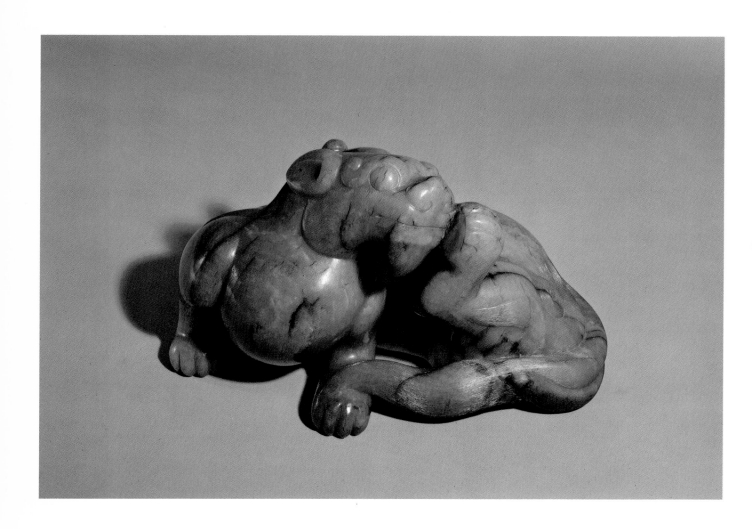

39. *Reclining Horse*. China;
late Ming or early Ch'ing
dynasty.
Jade (green and black
nephrite); L. 9¼ in., H. 5½
in.

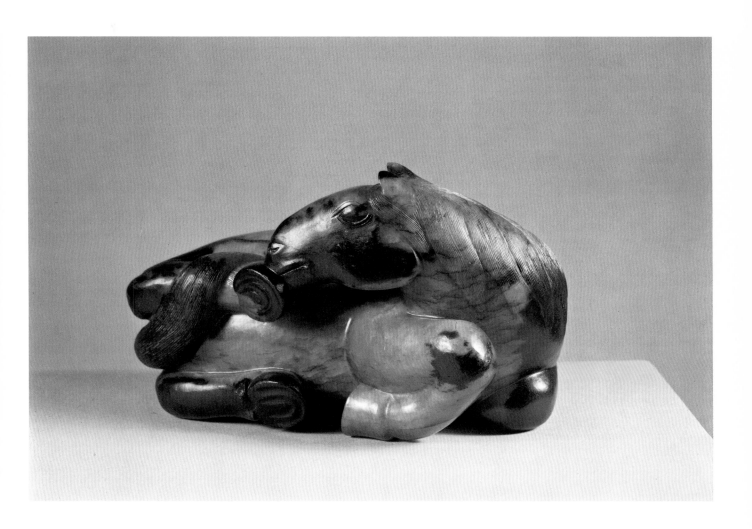

37. *Blue and White Vase.*
China; Ming dynasty,
early fifteenth century.
Porcelain; H. 7⅜ in.

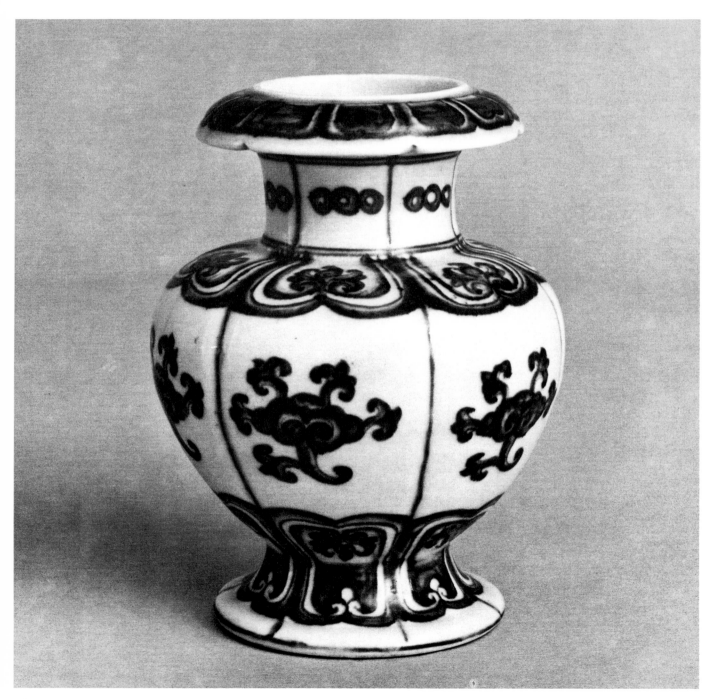

40. *Reclining Horse*. China;
Ming dynasty (1368–1644)
or slightly earlier.
Brown lacquer; H. 8 in.,
L. 14 in.

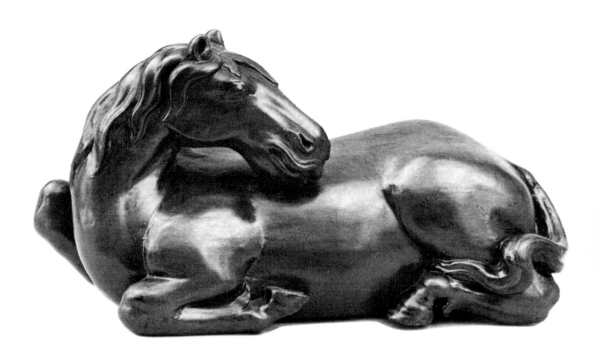

41. *Tray with Landscape Design.* China; Ming dynasty, probably reign of Yung Lo, 1403–1424. Carved cinnabar lacquer on wood (or cloth?); Diam. 13 ⅝ in.

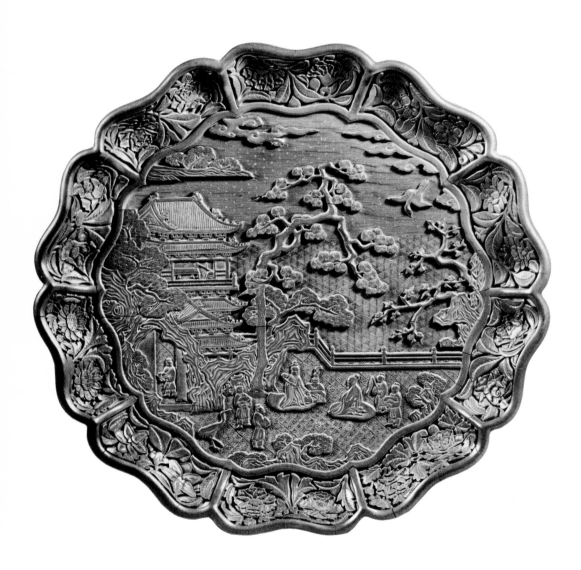

42. *Temple on a Mountain Ledge.* China; dated 1661. By K'un-ts'an (Shih-ch'i). Hanging scroll, ink and color on paper; H. 33 ½ in., W. 18 ¾ in.

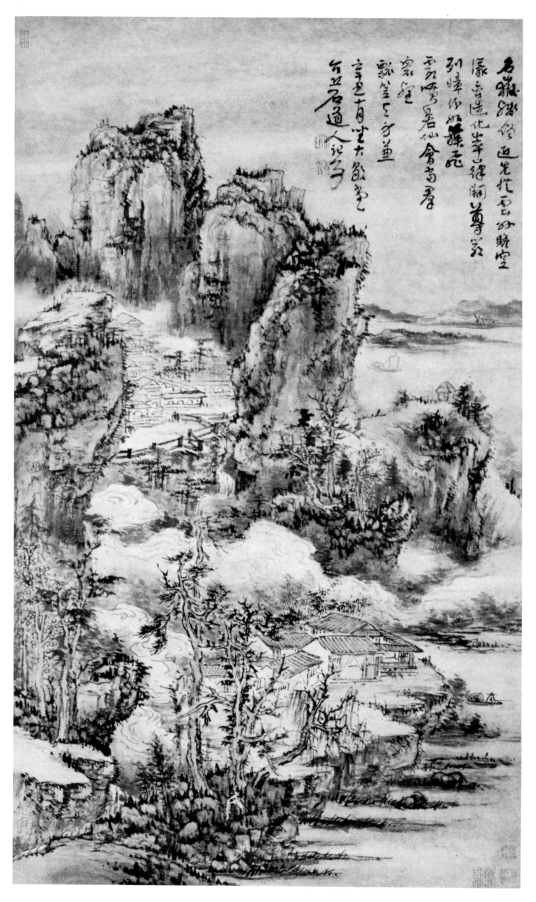

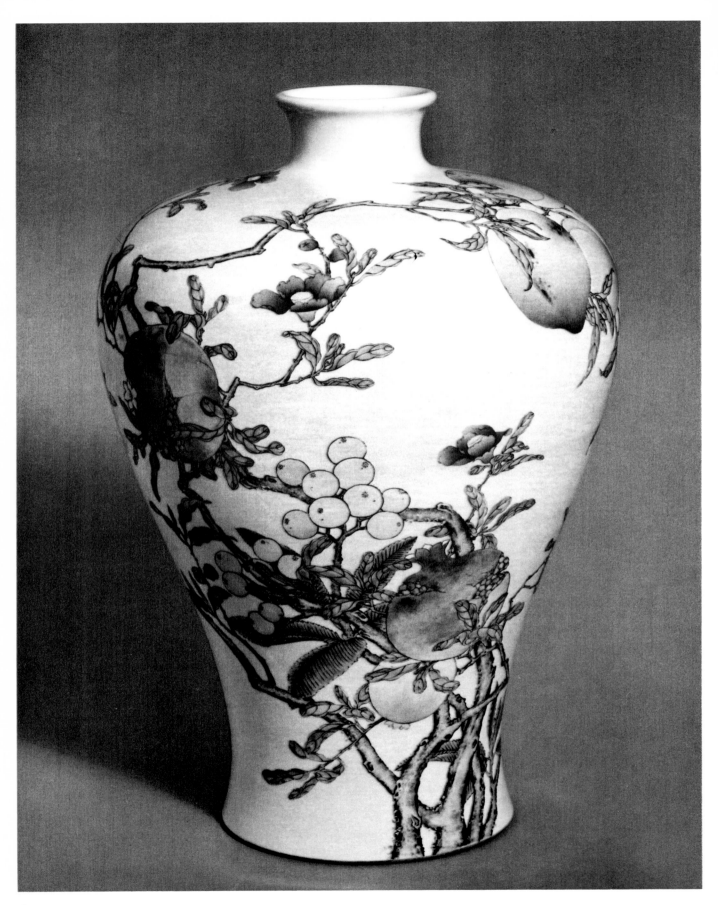

43. *Mei-P'ing* (*Plum Vase*).
China; Ch'ing dynasty,
mark and reign of
Yung Cheng, 1723–1735.
Porcelain with *famille rose*
enamels; H. 13 ½ in.
(*opposite*)

44. *Pair of Famille Rose
Bowls*. China; Ch'ing
dynasty, mark and reign of
Yung Cheng, 1723–1735.
Porcelain; Diam. 5 ⅝ in.

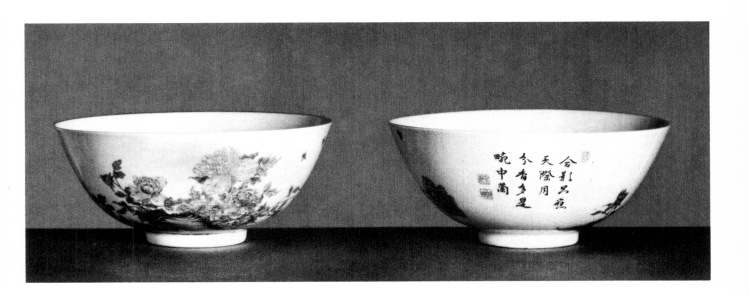

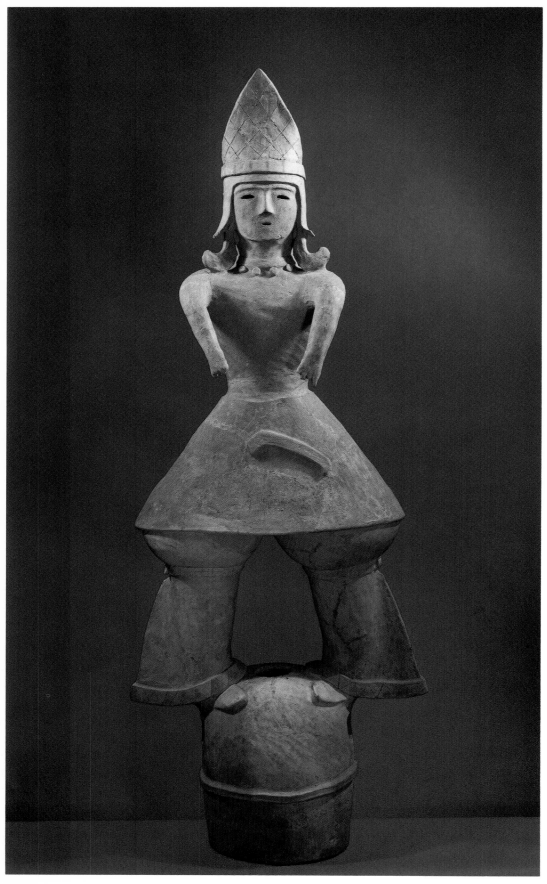

46. *Haniwa Figure of a Man.*
Japan, Ibaraki Prefecture;
late Kofun period,
sixth–seventh century.
Clay; H. 56 in.

47. *Box Cover*. Japan;
Tempyo period, 710–794.
Gold and silver inlays in lac-
quer on leather (*heidatsu*);
H. 3¾ in., L. 16¼ in.

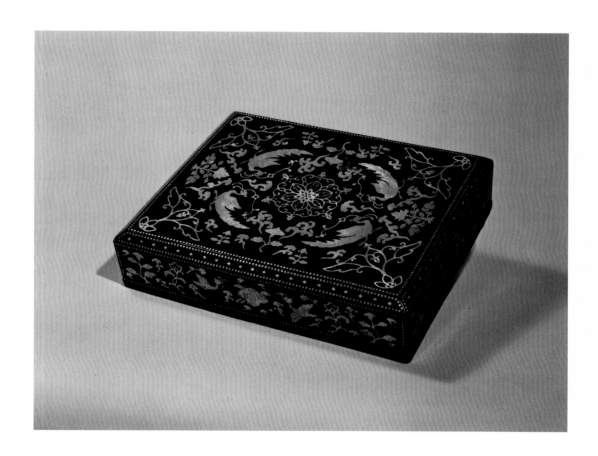

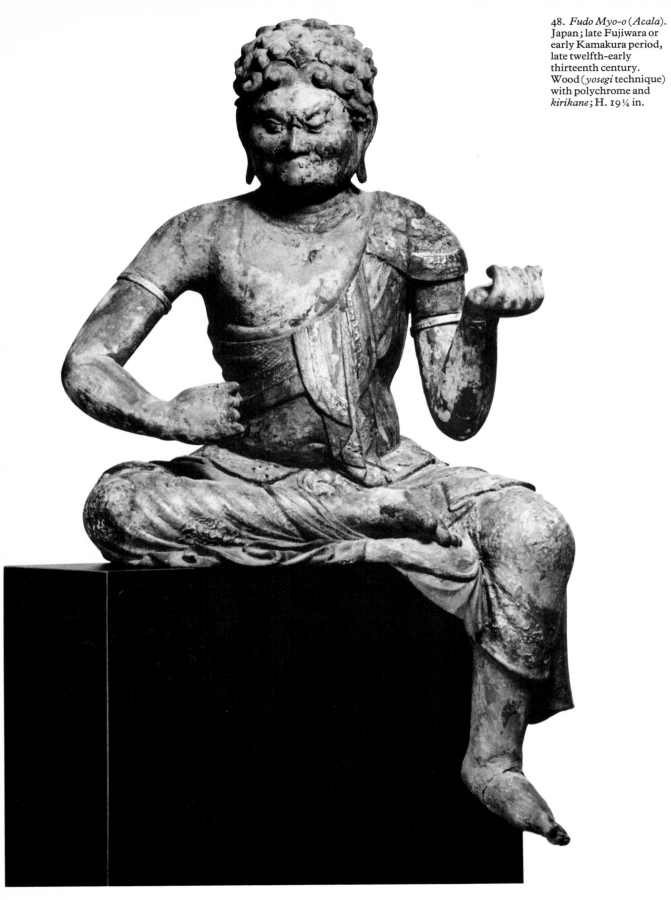

48. *Fudo Myo-o* (*Acala*). Japan; late Fujiwara or early Kamakura period, late twelfth–early thirteenth century. Wood (*yosegi* technique) with polychrome and *kirikane*; H. 19¼ in.

45. *Figurine*. Japan;
late Jomon period,
ca. 1200–200 B.C.
Gray earthenware with some
black reduced areas, traces
of red pigment on the
headdress; H. 9¾ in.

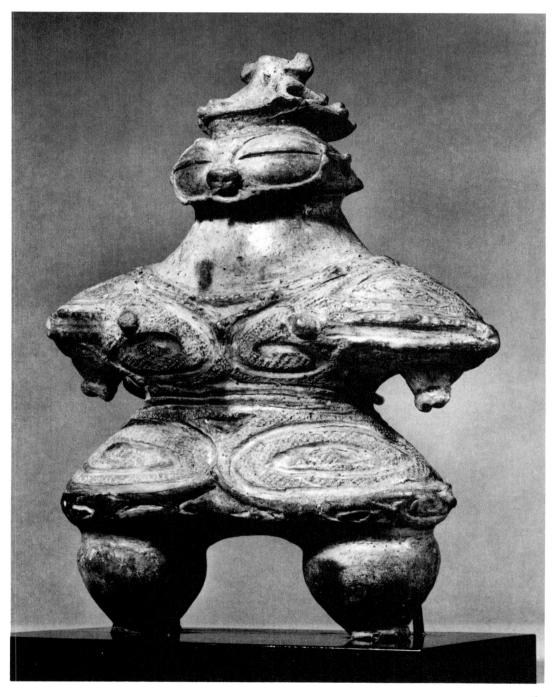

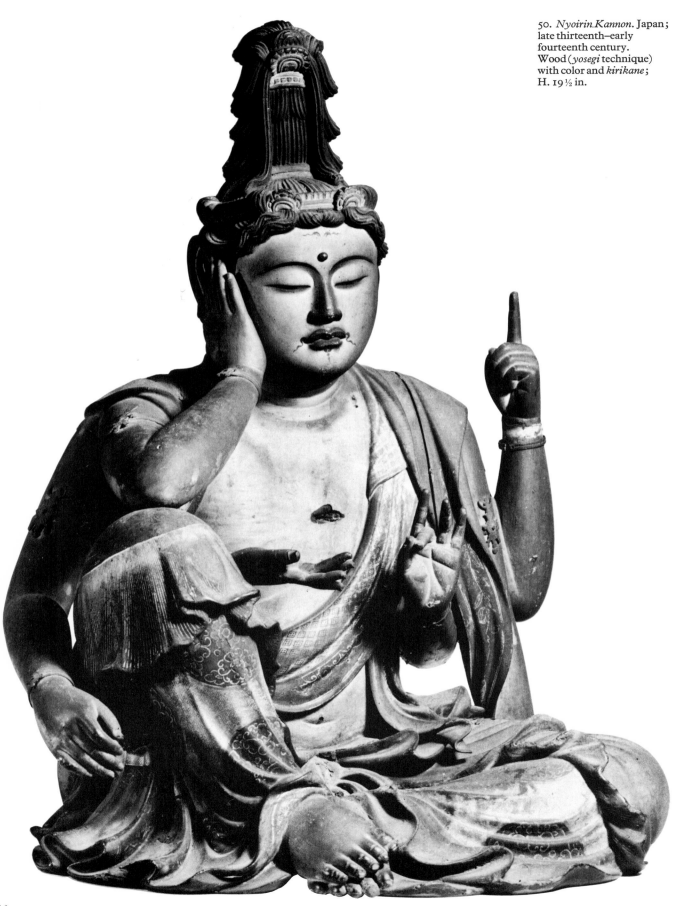

50. *Nyoirin Kannon.* Japan;
late thirteenth–early
fourteenth century.
Wood (*yosegi* technique)
with color and *kirikane*;
H. 19 ½ in.

51. *Pair of Komainu*
(*Korean Lions*). Japan;
fourteenth century.
Wood, carved, gilded, and
polychromed; H. 13½ in.

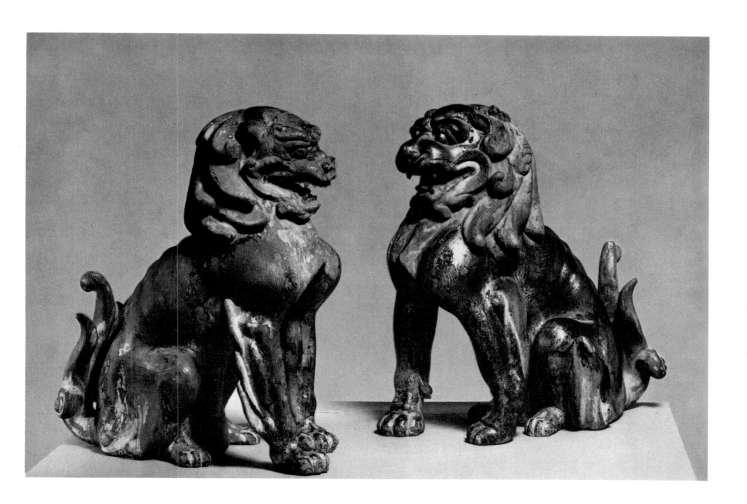

49. *Shakyamuni*. Japan;
Kamakura period,
1185–1333.
Wood (*yosegi* technique)
with paint and *kirikane*;
H. 47 in.

52. *Dainichi Nyorai*. Japan;
Kamakura period,
1185–1333.
Hanging scroll, color on silk;
H. 43 ½ in., W. 32 ⅝ in.
(*opposite*)

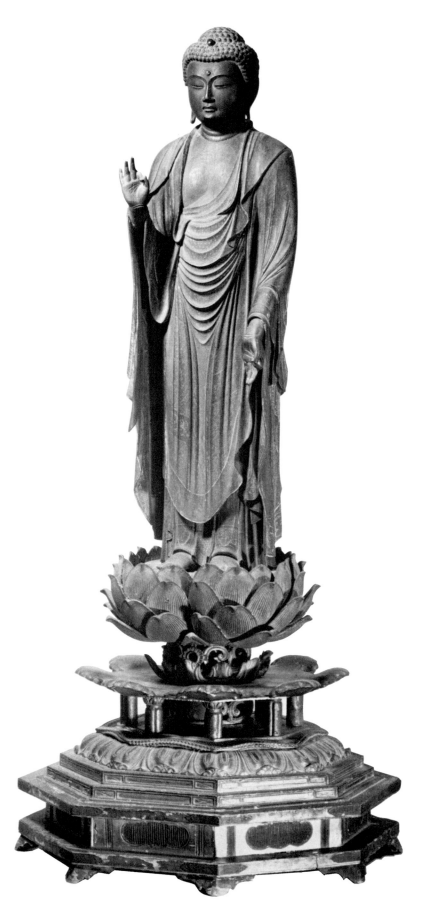

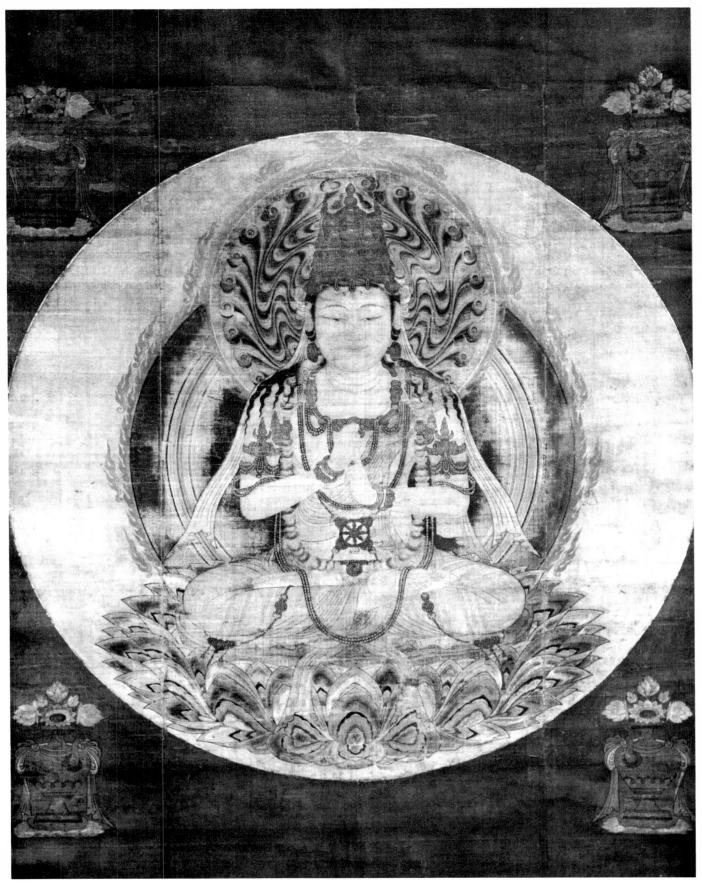

53. *Blue Fudo with Attendants*. Japan; Kamakura period, 1185–1333. Hanging scroll, ink and color on silk; H. 72 in., W. 45 in. (*opposite*)

54. *Shuya-do* (*Pavilion in a Beautiful Field*). Japan; early fifteenth century, before 1437. Hanging scroll, ink and very slight color on paper; H. 28 ¼ in., W. 11 ¼ in.

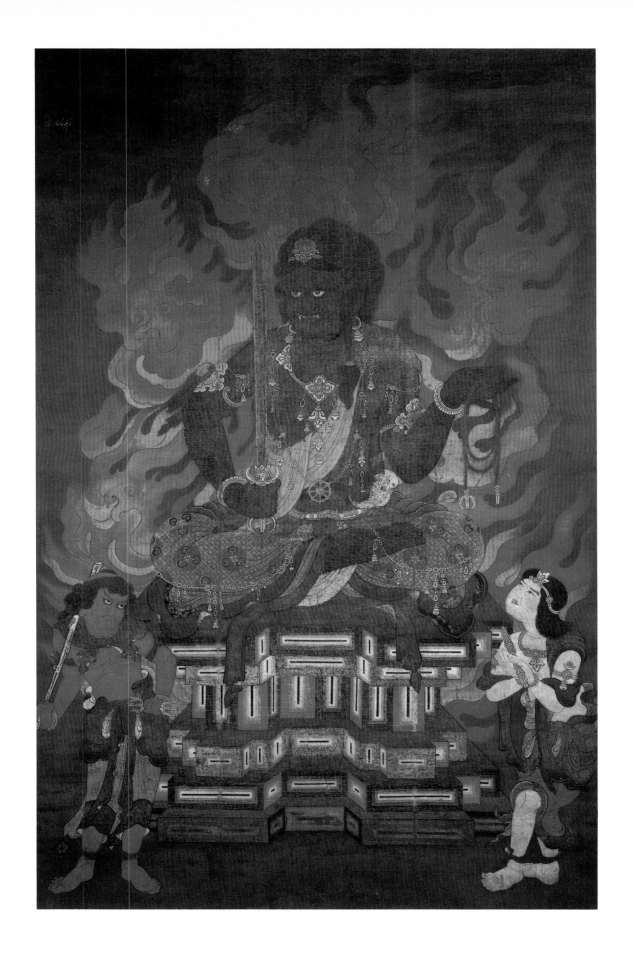

55. *Eight Scenes of Hsiao-Hsiang*. By Sesson (1504–1589). Japan; sixteenth century. Handscroll, ink on paper; H. 6¼ in., L. 114 in.

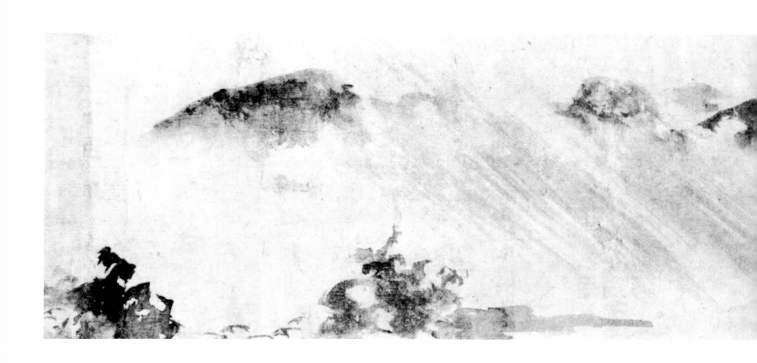

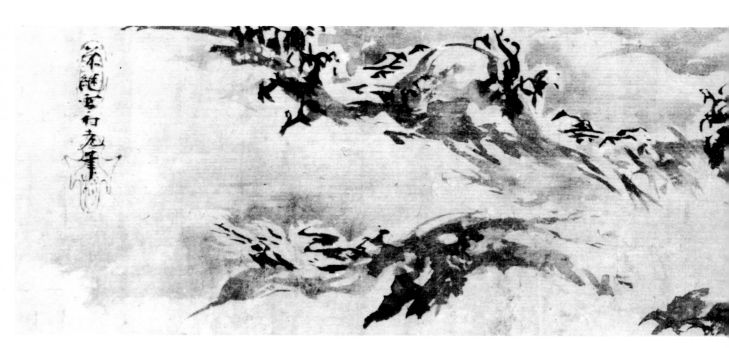

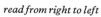

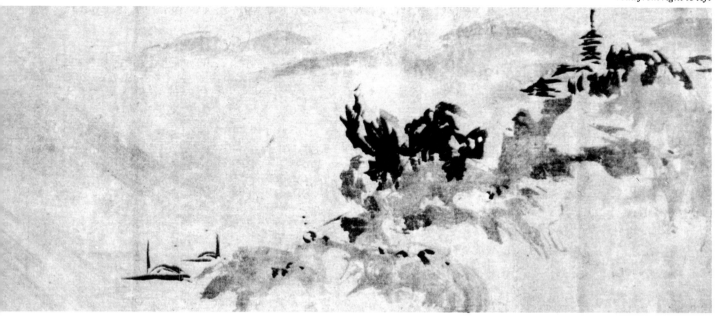

56. *The Four Seasons*. Japan;
Muromachi period,
1392–1593. Attributed to
Kano Motonobu
(1476–1559).
Pair of six-fold screens, ink
and slight color on paper;
H. 61 in., W. 142⅛ in.
each screen.

(*right screen*)

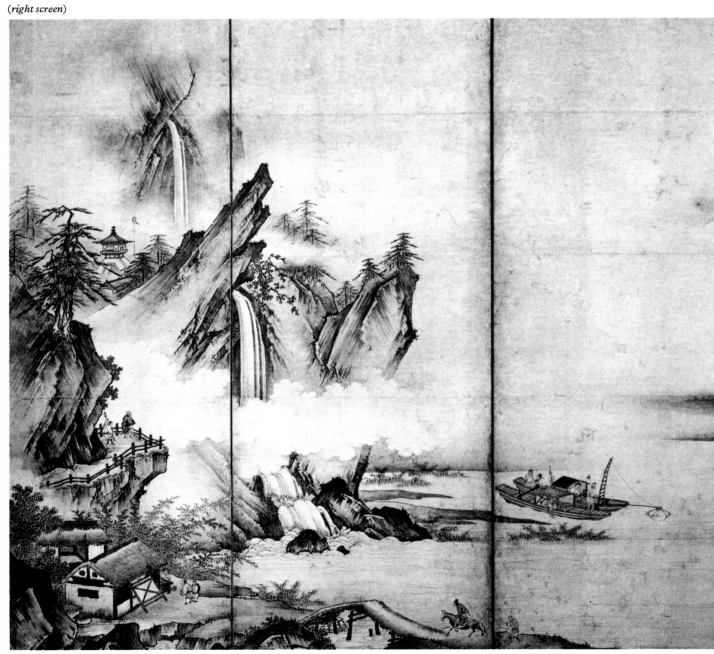

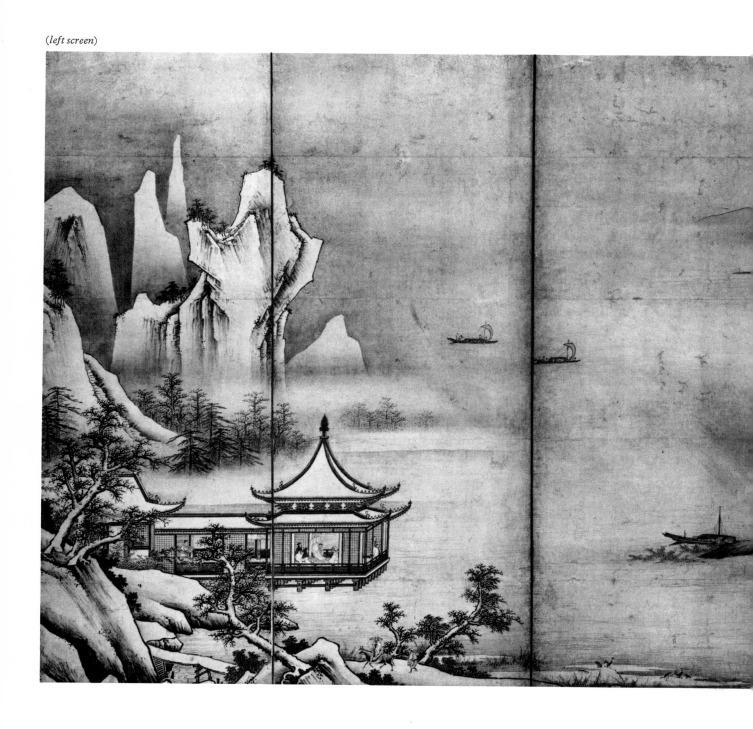

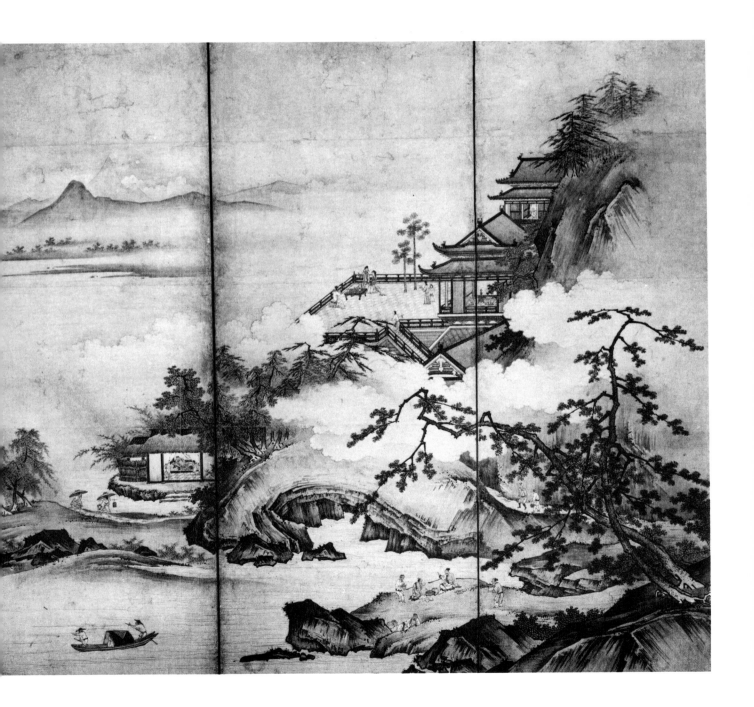

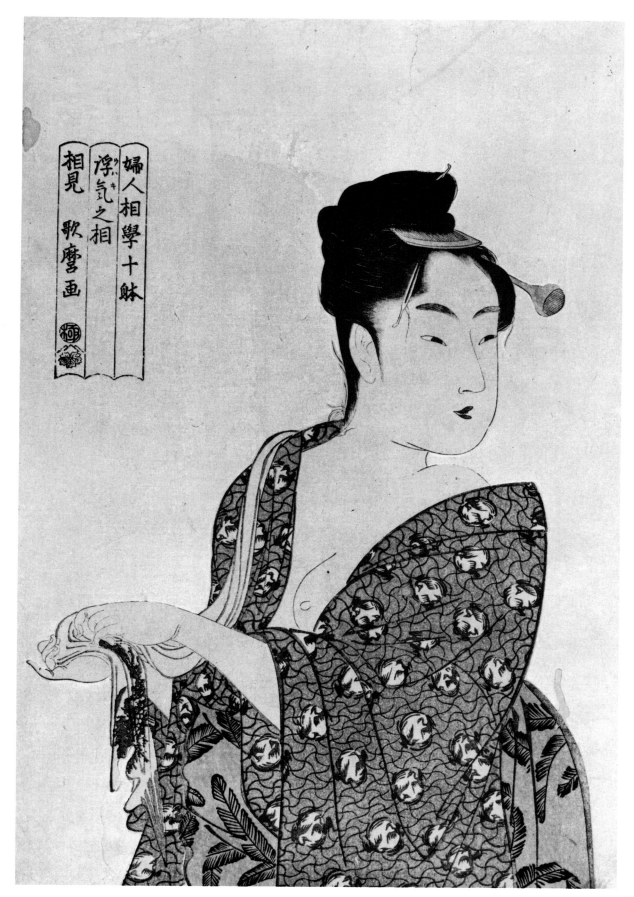

57. *Beauty Wringing Out a Towel*. By Kitagawa Utamaro (1753–1806). Japan; eighteenth century. Woodblock print; H. 14⅞ in., W. 9⅞ in. (*opposite*)

58. *Actor*. By Katsukawa Shunei (1762–1819). Japan; late eighteenth-early nineteenth century. Woodblock print; H. 14½ in., W. 9½ in.

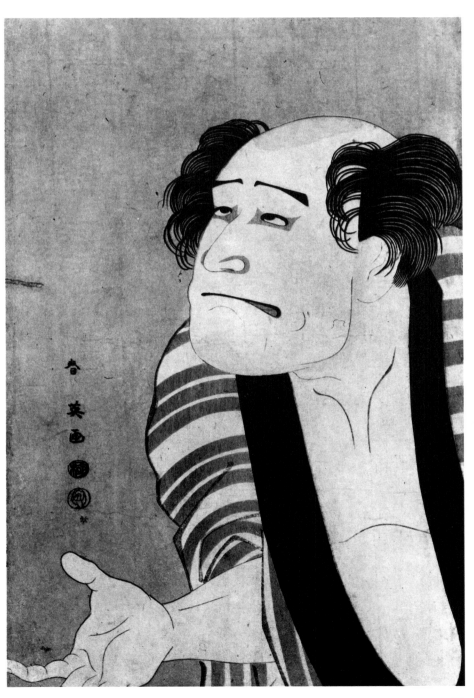

59. *Two Actors*. By Toshusai
Sharaku (active 1794–95).
Japan; eighteenth century.
Woodblock print; H. 14¾ in.,
W. 10 in. (*opposite*)

60. *Lady and Screen*. By
Eishosai Choki (active
1785–1805). Japan;
late eighteenth-early
nineteenth century.
Woodblock print;
H. 14¼ in., W. 9¾ in.

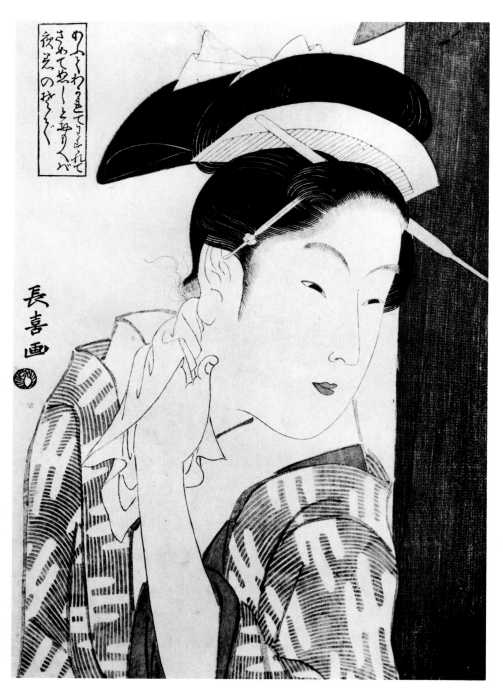

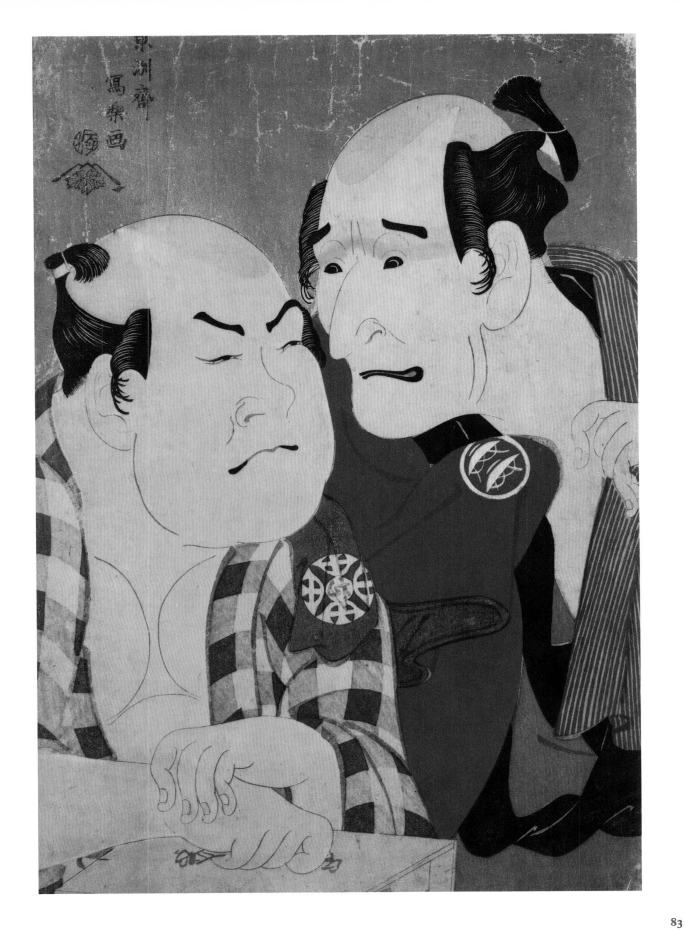

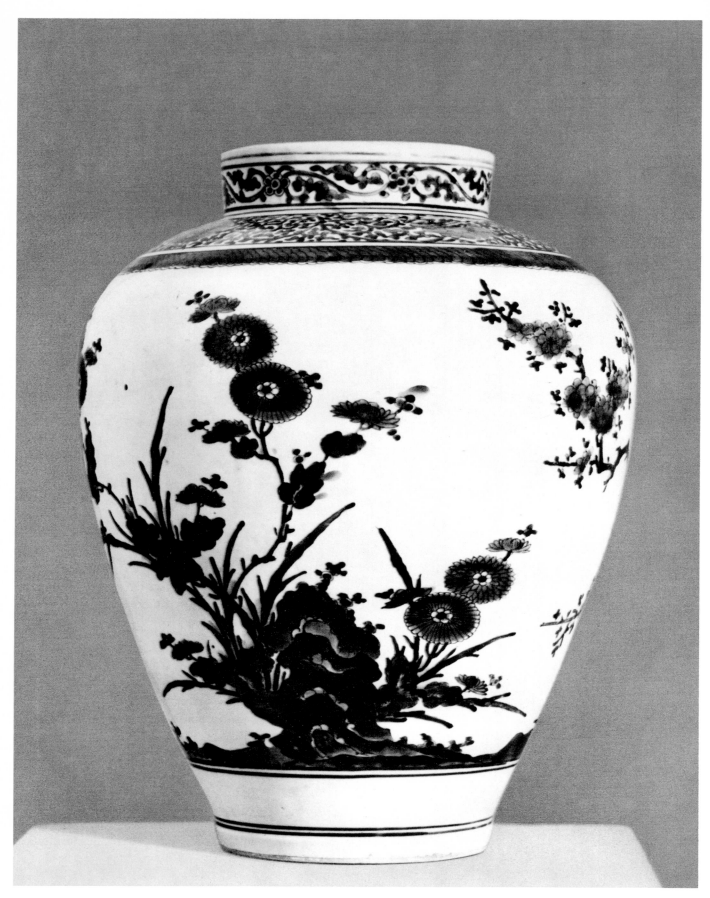

61. *Blue and White Jar.*
Japan; late seventeenth
century.
Porcelain, *Imari* ware (?);
H. 18¾ in. (*opposite*)

62. *Bottle-shaped Vase.*
Japan; late seventeenth
century.
Enameled porcelain,
Kakiemon style, H. 15¾ in.

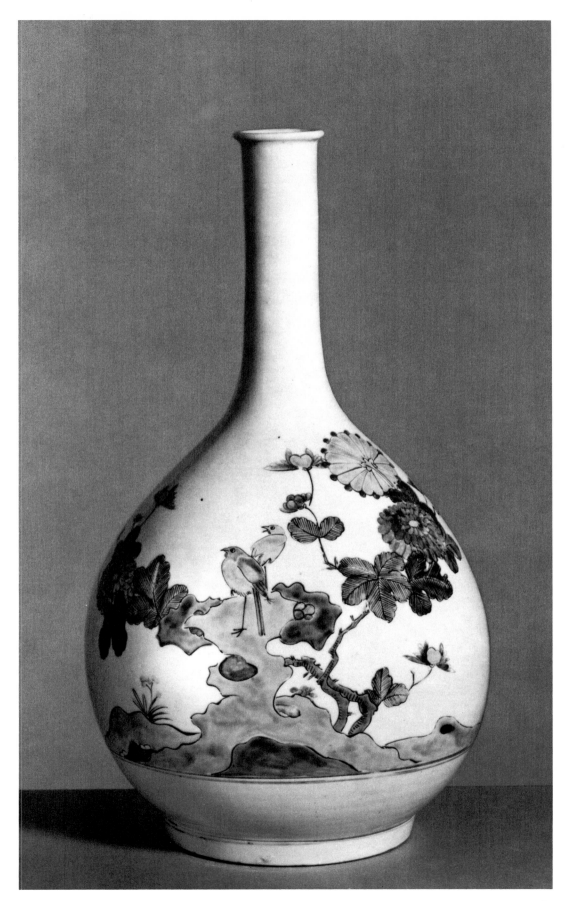

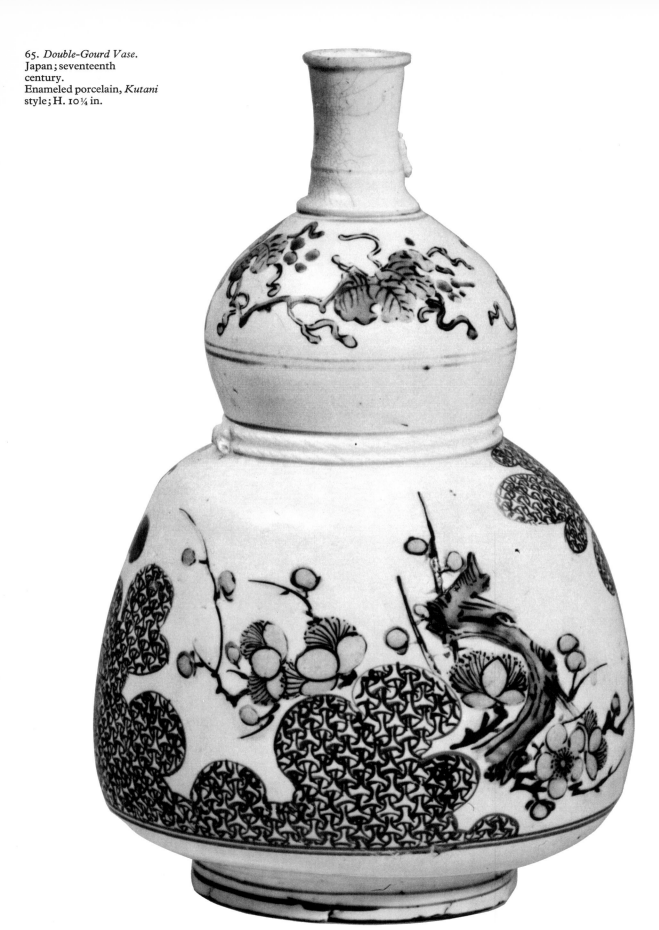

65. *Double-Gourd Vase.*
Japan; seventeenth
century.
Enameled porcelain, *Kutani*
style; H. 10¼ in.

63. *Pair of Mandarin Ducks.*
Japan; late seventeenth
century.
Enameled porcelain,
Kakiemon style;
Drake, H. 5 in., L. 7⅝ in.;
Hen, H. 4½ in., L. 7⅜ in.

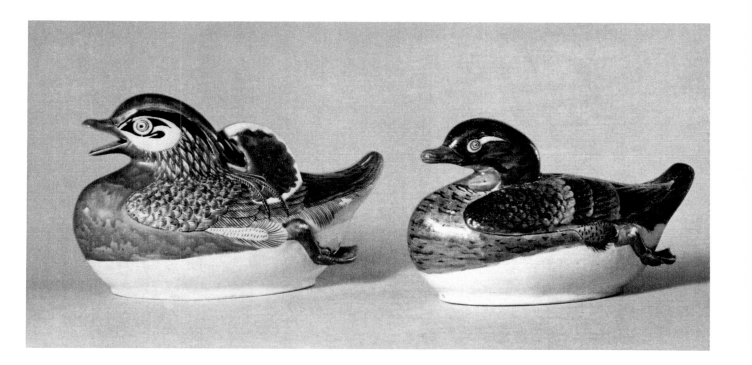

64. *Plate with Chrysanthemum Design.* Japan; late seventeenth century. Enameled porcelain with underglaze blue, *Nabeshima* ware; Diam. 7¾ in.

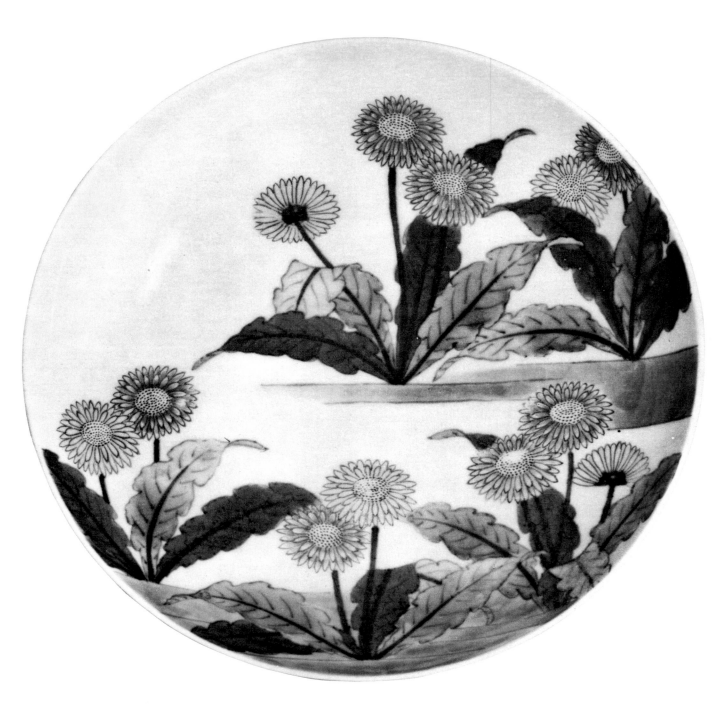

66. *Dish on a High Foot.*
Japan; seventeenth
century.
Enameled porcelain, *Ko*
(Old) *Kutani* ware;
H. 4 in., Diam. 11 ½ in.

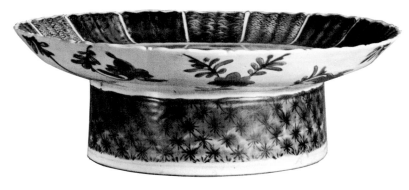

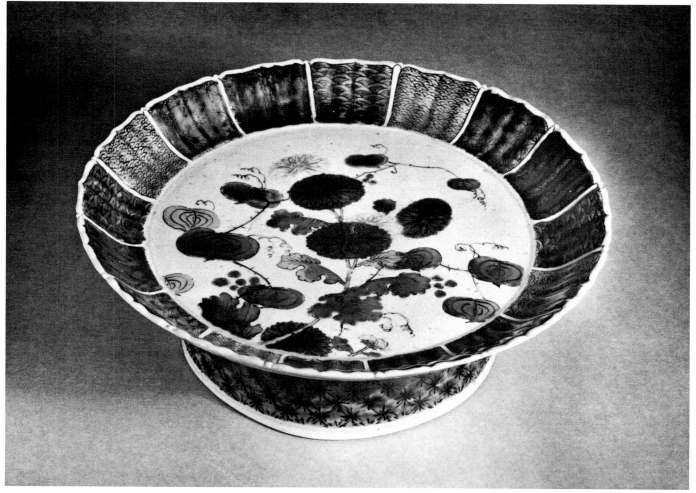

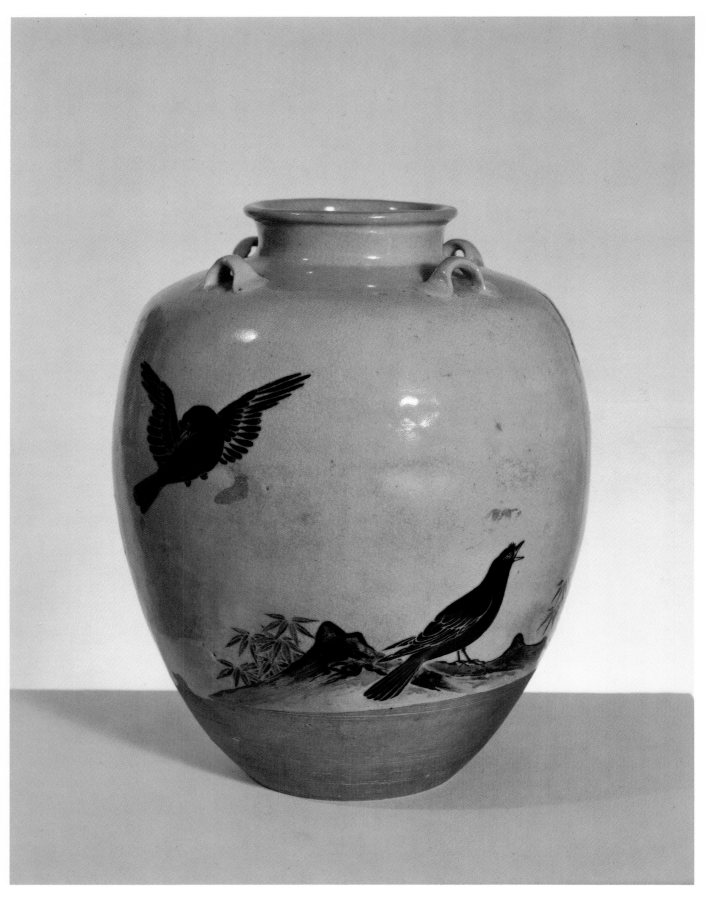

67. *Tea Jar*. By Nonomura
Ninsei (active before 1650
and after 1677). Japan;
seventeenth century.
Stoneware; H. 12 in.

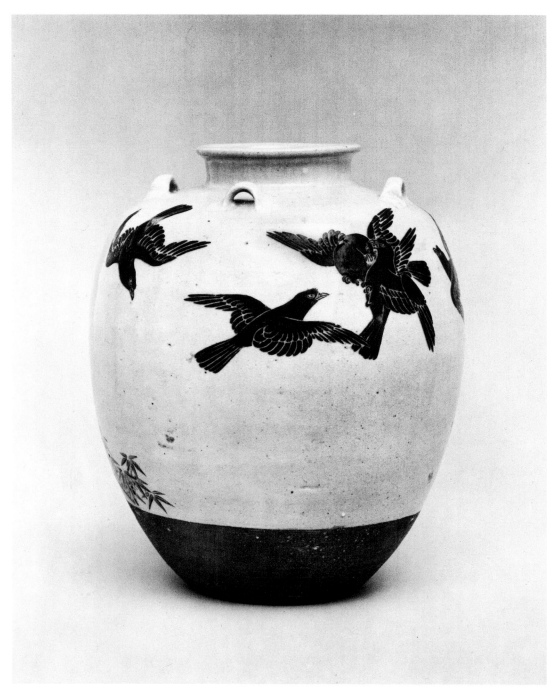

68. *Celadon Bowls and
Saucers*. Korea;
Koryu dynasty, 918–1392.
Porcelain;
Saucers, Diam. 6¼ in.;
Bowls, Diam. 5¾ in.

69. *Maebyong (Vase)*. Korea;
Koryu dynasty, 918–1392.
Celadon-glazed porce-
laneous stoneware;
H. 15⅛ in. (*opposite*)

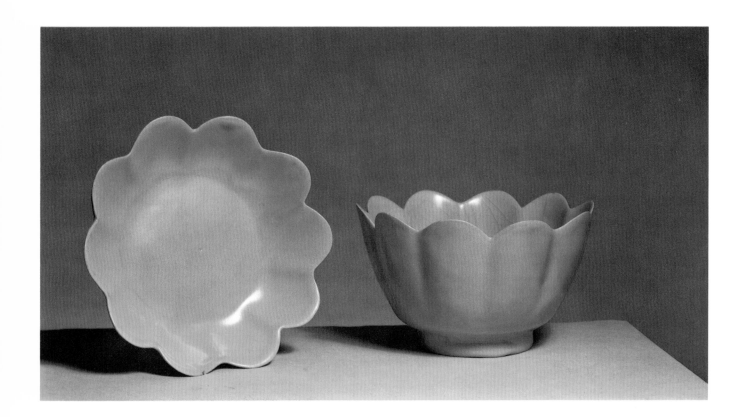

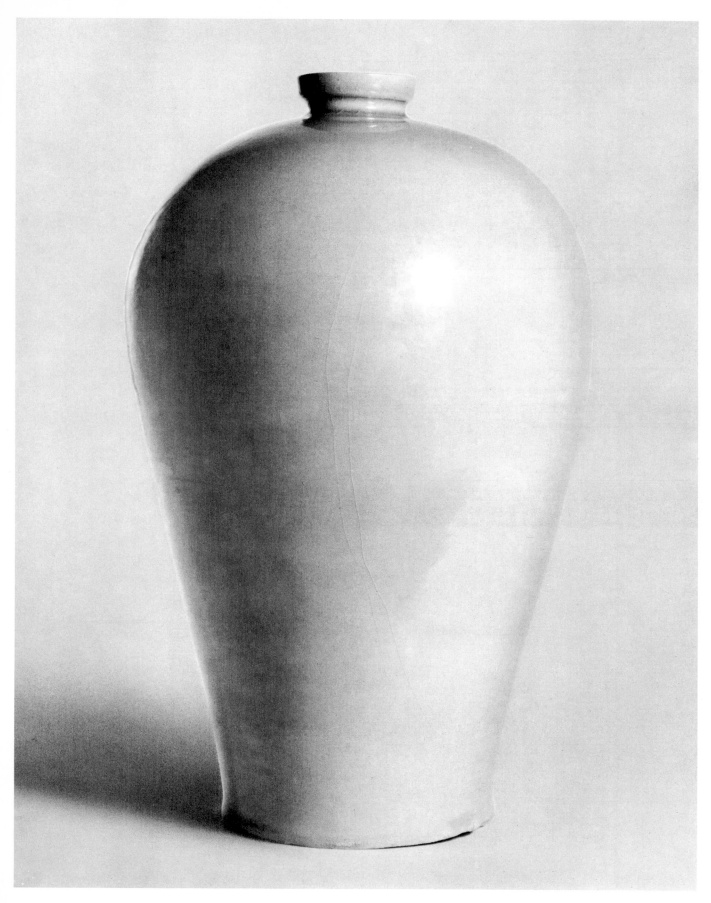

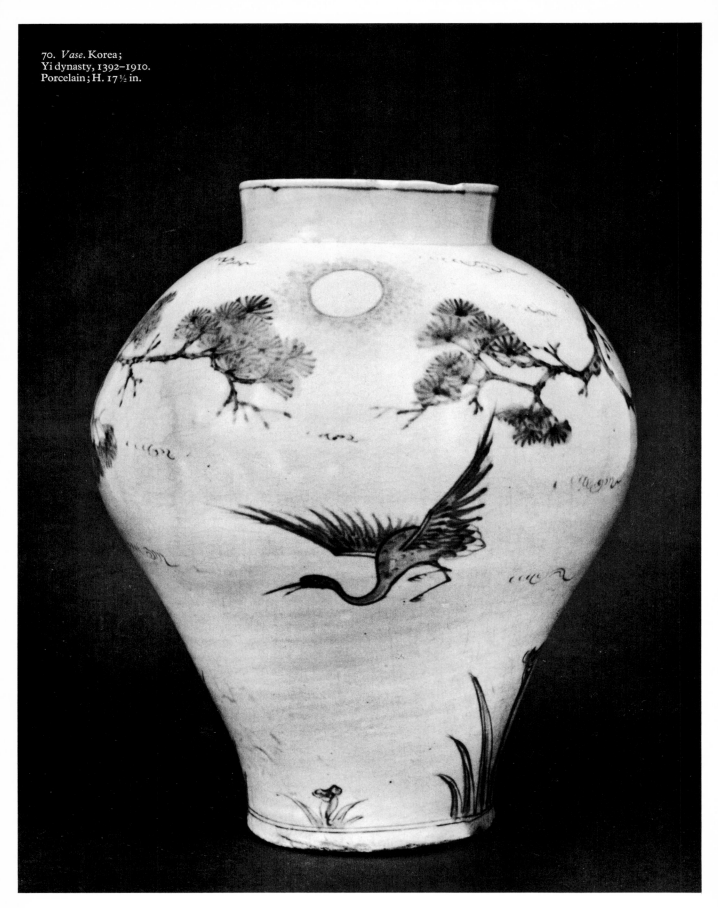

70. *Vase*. Korea;
Yi dynasty, 1392–1910.
Porcelain; H. 17½ in.

19. Yu

China; early Chou period, ca. 1027 B.C.
Bronze; H. 12¾ in.

K'uei (dragons) decorate the bail handle of this *Yu*, and feline masks with flattened horns fasten it to the body, which has a brown-green patina. Bands of *t'ao t'ieh* and *k'uei* encircle the upper part of the body and the foot and there is another band of decoration on the lid. *Yu* of this type are often encountered without the band of decoration on the base. An inscription on the interior of the base reads *Fu* (father) *K'uei*. A comparable example, but with more clearly delineated *k'uei* in flat rather than rounded relief and with "bottle horned" heads at the ends of the handle, is in the Ingram Collection of the Ashmolean Museum, Oxford (see J. P. Dubosc, *Mostra d'Arte Cinese* [Venice, 1954], no. 53). See also the vessels in W. P. Yetts, *The George Eumorfopoulos Collection* (London, 1929–32), vol. I, pl. XVIII; and the Victoria and Albert Museum *Yu* in W. Watson, *Ancient Chinese Bronzes* (London, 1962), pl. 16.

Formerly Paul Mallon Collection.

20. P'an (Basin)

China; Western Han dynasty, 206 B.C.–A.D. 9
Bronze, engraved and gilded, with silver inlays;
Diam. 20 in.

The rim shows a scroll and chevron pattern while the interior registers are separated by bands composed of alternating dark and light triangles. The narrow outer register contains cloud and hook patterns with occasional small animals. The next register contains at least twenty-five animals and figures against cloud-scroll and stylized mountain patterns—tortoises, *lung ma* (composite beasts with one horn), goats, dragons, toads, tigers, humanoid wind-spirits and birds. The inner circle has at its center a foliate design indicating the four directions, with a lion, a tiger, a one-horned, and a two-horned dragon at the four quarters, all similarly shown against cloud and mountain patterns.

The exterior and base are also divided by bands into registers. The main outer band contains apes, *lung-ma*, dragons, wind-spirits, peacock-phoenixes, tortoises, serpents, and tigers. The central medallion of the base is decorated with a long, sinuous two-horned dragon. The casting is heavy and solid. Four sets of paired lugs are placed beneath the rim on the exterior, suggesting some kind of quadruped support for the basin.

The extraordinary size and quality of this piece make it one of the most important of all known early Han bronzes. The types of wind-spirits and phoenix are related to those on the inlaid tube at the Tokyo Art School (see S. Lee, *A History of Far Eastern Art* [New York, 1964], figs. 53, 54), while the nearest parallel in shape and technique is a *p'an* in the Hosokawa Collection, no. 339 in the work by Umehara cited below. The liveliness of the figures and animals as well as the consummate technique reflect the high state of painting and of metal techniques in the early Han period.

Published: S. Umehara, *Nihon Shucho Shina Kodo Seika* [Selected Relics of Ancient Chinese Bronzes from Collections in Japan] (Osaka, 1959), vol. VI, no. 440.

21. Po-Shan-Lu (Hill Censer)

China; Eastern Han dynasty, 25–220
Gilt bronze; H. 5½ in.

A dish acts as the base for the censer, supporting a coiled dragon which in turn supports a flower-like quatrefoil (see No. 20, where the same shape on the interior indicates the four directions). The censer proper rises from the quatrefoil, its base simply banded but with an elaborately cast lid in the form of a many-peaked mountain, with striated hummocks in which numerous animals are represented in low relief: tortoise, lion, monkey, fox (?), deer, and a dog or wolf.

Published: J. Fontein and T. Wu, *Unearthing China's Past* (Boston: Museum of Fine Arts, 1973), illus. p. 103.

22. Dish

China; sixth century
Silver gilt with repoussé design; Diam. 4 15/16 in.

A hunting scene appears on the central area of this eight-lobed dish with foliate rim. The rim is decorated with a peony and arabesque design. The lobed sections have alternating designs of leaf and pomegranate arabesques, and flying parrots within leaf arabesques. The central scene shows rolling, overlapping hills in which a lion and a deer sport above, two men attack two serpents in the middle ground, and a hunting dog (?) and a long-sleeved rider on horseback move from right to left in the foreground.

The landscape background seems somewhat more developed than is common in Han dynasty tiles from Szechuan, but it is certainly not as fully rendered as the landscapes of the T'ang dynasty. The floral arabesques and ornaments reveal Near Eastern Sassanian and Sogdian influence, and this type of decoration could well have occurred in the later Six Dynasties period or in the Sui dynasty. The sixth-century date seems the most likely.

23. Seated Buddha

China; Northern Ch'i dynasty, dated 551
Gilt bronze; H. 7⅛ in.

The Buddha, probably a Maitreya, sits with the right leg pendant and holds an object, possibly a jar or lotus bud, in his raised right hand. The foliate halo and lotus base recall earlier gilt bronzes, but the full, rounded sculptural style is characteristic of the Northern Ch'i period.

An inscription on the back of the figure reads: "This statue was respectfully made by Wang Kuang-jên on the sixth day of the fourth month in the second year of the T'ien-pao era (A.D. 551)."

Published: S. Matsubara, *Chinese Buddhist Sculpture* (Tokyo, 1961), p. 117.

24. Mirror

China; T'ang dynasty, 618–907
Bronze, with gold and silver inlays in lacquer
(*heidatsu*); H. 5⅞ in., W. 5⅞ in. *illus. p. 39*

The technique used here on the back of the mirror is known in Japan as *heidatsu* and it is quite rare (examples may be seen in the Nezu Museum, Tokyo; the Shoso-in, Nara; The Cleveland Museum of Art; the Museum of Fine Arts, Boston; The Minneapolis Institute of Arts (*The Arts of the T'ang Dynasty* [Los Angeles: Los Angeles County Museum, 1957], no. 145); and The City Art Gallery, Bristol, England (*idem.* no. 146). In *heidatsu* technique, sheets of gold and silver were inlaid on a lacquered ground, and incised before the subsequent coats of lacquer had become completely hard (see also No. 47). Small birds, butterflies, and cranes holding floral sprays in their beaks cover the mirror in a symmetrically repeated design. The boss, within the central medallion, has an inlaid bow-knot design in silver. The bronze is silver in color with some green patination. The oblate square shape with indented corners is unique among known *heidatsu* mirrors.

25. Court Lady with Cymbals
China; T'ang dynasty, 618–907
Lead-glazed pottery; H. 13½ in. *illus. p. 42*

The seated figure has *san-ts'ai* (three-color) glazes of blue, yellow, and brown. In the fashion of the day, the lady's hair is dressed with buns on either side of the head (one has been reattached). Remains of a flower design in relief, similar to that on the famous standing figure in the Hosokawa Collection, Tokyo, adorn her cheeks. The cymbal and the cord held in her right hand have been broken and repaired. The style of the wicker stool with its indented waist is of considerable rarity and is probably derived from the "double-seat" or throne of Maitreya, a common motif in Six Dynasties sculpture. One other example in T'ang figurines is published in *Toki Zenshu* [Collective Catalogue of Pottery and Porcelain], vol. 25 (Tokyo, 1961), no. 61, left.

Published: D. Lion-Goldschmidt and J.-C. Moreau-Gobard, *Chinese Art: Bronze, Jade, Sculpture and Ceramics* (New York, 1960), pl. 134.

26. Bowl
China; dated 1162
Olive-green glazed stoneware; H. 4⅝ in.,
 Diam. 8 in.

This most interesting and rare bowl combines the traditional lotus interior of the Northern Celadon vocabulary with an exterior border sometimes found in Tz'u-chou wares (see S. Mizuno [ed.], *Sekai Toji Zenshu* [A Complete Series on World Ceramics], vol. 10 [Tokyo, 1955], no. 114). The inscription written in ink (?) on a biscuit ring, on the base of the bowl's interior, reads, "Ta-ting jen-wu sui" (purchased in the year of *jen-wu* of the reign of Ta-ting [1161–1189, Chin dynasty]), the cyclical date corresponding to 1162. Such dates in ink are more often found on Tz'u-chou wares of the red and green type dating from the late Chin or early Yüan dynasty (see *Tokyo kokuritsu hakubutsukan zuhan mokuroku: Chugoku kotoji-hen* [Illustrated Catalogues of the Tokyo National Museum: Chinese Ceramics] [Tokyo: National Museum, 1965], nos. 307 [1201 A.D.] and 308 [1230 A.D.]).

The date on this piece is significant in demonstrating the continuation of the Northern Celadon tradition after the fall of the Chinese northern capital in 1127. An almost exactly comparable piece, without date, is in the Iwasaki Collection (Seikado Foundation) in Tokyo.

27. Hsi (Brushwasher)
China; Northern Sung dynasty, 960–1127
Chün ware, glazed stoneware; Diam. 7½ in.

The gently rounded sides of the *hsi*, a shallow bowl, rise to a rim which has a foliate-shaped flange designed to protect the small loop handle below. The soft-toned, milky, pale blue glaze, changing to buff at the rim, is evenly crazed. Three spur-marks appear on the flat rimless base, which shows slight stains and deterioration. A similar Chün brushwasher is in the Museum of Far Eastern Antiquities, Stockholm, and another in soft Chün ware, from the Ingram Collection, was exhibited at The Oriental Ceramic Society in 1952 (see *Chün and Brown Glazed Wares* [London, 1952], no. 196). The same form is found in contemporaneous silver in the Kempe Collection (see B. Gyllensvärd, *Chinese Gold and Silver in the Carl Kempe Collection* [Stockholm, 1953], no. 136).

Published: R. L. Hobson, *Chinese Pottery and Porcelain* (London, 1915), no. 79; The Oriental Ceramic Society Exhibition catalogues: *The Arts of the Sung Dynasty* (London, 1960), no. 43, pl. 23; *The Ceramic Art of China* (London, 1971), no. 80, pl. 53.

Formerly Mrs. F. Brodie Lodge; Albert Rutherston; Mrs. Blanco White Collections.

28. Bowl
China; Northern Sung dynasty, 960–1127
Chün ware, glazed stoneware; Diam. 3½ in.

The small porcelaneous stoneware bowl with splashes of purple is typical of Chün ware. The body color shows through on the lip where the characteristically opaque glaze is thin; where it is exposed at the foot and base it is burnt to tan and cinnamon brown. The purity of the colors and the excellent preservation of the surface are noteworthy.

29. Tea Bowl
China; Sung dynasty, 960–1279
Chien ware, glazed brownish purple stoneware,
 with silver rim; Diam. 4¾ in.

The six-dot floral decoration on the brown and black "hare's fur" glaze is apparently unique in Chien ware, but it is related to the same dotted floral decoration of Tz'u-chou wares from north China. Chien ware bowls were fashioned to fulfill the requirements of drinking tea: the thick glaze provided insulation for the cupped hand, while keeping the tea hot; the dark brown color permitted aesthetic appreciation of the green liquid; and the bowl's lip prevented dripping.

30. Hsi (Brushwasher)
China; Northern Sung dynasty, 906–1127
Honan stoneware with black "oil-spot" glaze;
 Diam. 6½ in.

This is a rare, large example of the uncommon "oil-spot" glaze found on Chien ware in Fukien province and then copied by the potters of Honan in north China. The white porcelaneous body is exposed in places on the base where the covering purple-brown slip is thin. There is slight restoration to the rim.

Published: *Mostra d'Arte Cinese*, no. 500; The Oriental Ceramic Society Exhibition catalogue, *Chün and Brown Glazed Wares*, no. 62.

Formerly Mrs. Alfred Clark Collection.

31. Cha Tou (Double Jar)
China; late T'ang dynasty
Gray-white porcelain body with brown-black
 glaze; H. 4⅜ in., Diam. 4⅜ in.

The low conical body tapers to a short narrow cylindrical neck, from which the very slightly concave rim flares to a greater width than the body. The jar is covered with a minutely speckled, almost black glaze, thinning to a whitish tone around the rim and coagulating in a line above the beveled edge of the solid splayed foot. On the base there are traces of an inscription which, according to William Willetts, corresponds to the date 841. The form, probably of Near Eastern origin, indicates a specific usage, possibly as a wine taster; a glass vessel of similar shape, perhaps of Persian origin, is in the Shoso-in, Nara.

Compare with a Chinese silver jar in the Kempe Collection, illustrated in B. Gyllensvärd, "T'ang Gold and Silver," *Bulletin of the Museum of Far Eastern Antiquities*, no. 29 (Stockholm, 1957), pl. 20c; reproduced also by W. Willetts, no. 181, in the work cited below. A Yüeh ware jar is illustrated in *Sekai Toji Zenshu*, vol. 9 (Tokyo, 1956), pl. 43a. For the same form in white ware, see B. Gyllensvärd, *Chinese Ceramics in the Carl Kempe Collection* (Stockholm, 1964), no. 295, also included in *Mostra d'Arte Cinese* no. 368; another, in the Royal Ontario Museum, is illustrated in Willetts (see below), no. 183.

Published: W. Willetts, *Foundations of Chinese Art* (London, 1965), no. 182.

Formerly Sir Herbert Ingram Collection.

32. Jar with Decoration of the
"Three Friends"
China; Yüan dynasty, 1280–1368
White porcelain with underglaze red; H. 20½ in.

In descending order the decoration is divided into registers of hanging cloud collars, rising gadroons with floral inserts, and a peony scroll arabesque. In the principal register large pines, prunus, and bamboo—the popular motif known as "Three Friends of the Wintry Season" (*shui-han san-yu*)—are supplemented by other scholar's delights such as plaintain, fungus, old rocks, peonies, and lilies. At the foot of the jar gadroons with formal floral vajra inserts are separated into two sections by a narrow band of key fret, and a curling arabesque adorns the base. The rim of the mouth has been ground down, presumably because of damage.

The large and splendid drawing of the bold design

makes this one of the finest known underglaze red examples of the fourteenth century. The color is largely a silvery gun-metal gray, often found in jars of the period. The nearest comparable example is in The Palace Museum in Peking* (see Y. Mayuyama, *Chugoku bumbutsu Kenbun* [Experiences in Chinese Art] [Tokyo, 1974], pl. 203). See also the cut-down bottle vase with "Three Friends" decor from the Addis Collection, in S. Lee and W. Ho, *Chinese Art Under the Mongols: The Yüan Dynasty (1279–1368)* (Cleveland, 1968), no. 171, and pp. 97–104 for discussion of the motif.

* The author is indebted to Sir John Addis, Her Majesty's Ambassador to the People's Republic of China, for this information.

33. Ewer
China; Ming dynasty, reign of Yung Lo,
 1403–1424
Porcelain; H. 13 in.

Peony scroll decorations appear on numerous examples of Yung Lo white ware. Here it has been incised beneath the transparent glaze in a technique approaching "secret decoration" (*an-hua*). The shape is derived from Near Eastern sources and is found in blue and white, underglaze red, and plain white examples from the Yüan dynasty onward. The tip of the spout is repaired. Two comparable Yung Lo examples are shown in *Toyo to-ji ten: Chukoku, Chosen, Nihon* [Exhibition of Far Eastern Ceramics: Chinese, Korean, and Japanese] (Tokyo; National Museum, 1970), no. 88 in underglaze red, no. 89 in white. A ewer of similar form, with underglaze red decoration, is reproduced in Lee and Ho, *Chinese Art Under the Mongols*, no. 172. Apparently the only example with a cover is in the Victoria and Albert Museum (see S. Jenyns, *Ming Pottery and Porcelain* [London, 1953], pl. 19).

34. Jar with Peony Decoration
China; Ming dynasty, fifteenth century, probably
 reign of Yung Lo, 1403–1424
Porcelain with decoration in underglaze blue;
 H. 9⅜ in.

This jar may have once had a cover. Its pure white and "heaped" blue are characteristic of Yung Lo wares. Related examples are shown in R. Y. d'Argencé, *Chinese Ceramics in the Avery Brundage Collection* (San Francisco, 1957), pl. LII (B), and *Toyo toji ten...*, fig. 93.

35. Blue and White Dice Bowl
China; Ming dynasty, mark and reign of
 Hsüan Te, 1426–1435
Porcelain; H. 4½ in., Diam. 11⅞ in.

The massively potted bowl is decorated in a strong purplish tone of underglaze blue with the "Three Friends"—pine, prunus and bamboo. Each motif is repeated, and grows from a band of gadroon panels. Breaking waves encircle the foot; the porcelain exposed on its wide rim is burnt orange around the margins of the glaze. The interior is entirely plain. The six-character mark of Hsüan Te appears in a horizontal line under a double-line border below the rim.

For a similar bowl, in the Percival David Founda-

tion, see *Catalogue of the International Exhibition of Chinese Art at the Royal Academy of Arts*, Burlington House, London, 1935–36 (London, 1935), no. 1455, also illustrated in A. D. Brankston, *Early Ming Wares of Chingtechen* (Peking, 1938), pl. 14, and M. Medley, *Illustrated Catalogue of Porcelains Decorated in Underglaze Blue and Copper Red in the Percival David Foundation of Chinese Art* (London, 1963), section 3, no. B 619. Another example is in the Cleveland Museum of Art (see *Handbook* [1969], p. 266). Bowls of this shape are recorded among Hsüan Te marked wares with a variety of patterns, including dragons, fruiting branches, and scrolling peonies.

36. Chi-Hung (Sacrificial Red) Dish

China; Ming dynasty, second half of the fifteenth century, probably reign of Ch'eng Hua, 1465–1487
Porcelain with underglaze red; Diam. 6⅝ in.

illus. p. 49

A deep "sacrificial red" color brings distinction to this saucer-shaped dish. Below the white rim, its shallow rounded sides are covered with a rich speckled copper-red underglaze, which is somewhat more opaque in the bottom of the dish and around the shallow foot. The white glaze inside the foot is of bluish tint. The delicate potting of this piece and, in particular, the thinly potted foot rim suggest an attribution to the reign of Ch'eng Hua, whose *nien hao* (reign name) is apparently unrecorded on copper-red wares.

Published: The Oriental Ceramic Society Exhibition catalogues: *Monochrome Porcelain of the Ming and Manchu Dynasties* (London, 1948), no. 127; *The Arts of the Ming Dynasty* (London, 1957), no. 100.

Formerly R. H. R. Palmer Collection.

37. Blue and White Vase

China; Ming dynasty, early fifteenth century
Porcelain; H. 7⅜ in.

illus. p. 56

The vase has a six-lobed baluster shape. The oviform body is painted with vertical panels of fungus. At the top is a border of formal petals enclosing leaf sprays. A matching border around the lower part of the body extends downward over the foot. The neck is decorated with six groups of three joined circles; the downward-turned rim, also slightly lobed, has a border of broad petals. Compare a similar vase reproduced in Medley, *Catalogue of the Percival David Foundation of Chinese Art*, section 3, no. B 634.

Published: *Mostra d'Arte Cinese*, no. 630.

Formerly H. R. N. Norton Collection.

38. Chimera (?)

China; Sung to Ming dynasty, 960–1644
Green-gray jade with brown fissures; L. 12 in., H. 8 in.

illus. p. 54

The figure may be a *pi-hsieh*, a composite auspicious animal not unlike the chimera. The dating of this large and rare sculpture is a difficult and still exploratory matter; it could be as early as the T'ang dynasty but not much later than the Yüan.

The remarkable sculptural character of the piece, conceived in the full round, places it outside the usual "applied arts" realm normally assigned to jade carvings. The only remotely comparable example known to me is that reproduced in B. Laufer, *Jade* (Chicago, 1912), pl. XLIII, opp. p. 311.

39. Reclining Horse

China; late Ming or early Ch'ing dynasty, seventeenth century
Jade (green and black nephrite); L. 9¼ in., H. 5½ in.

Brown-black portions of the stone, which contrast strongly with the green, have been strategically utilized to bring out the form and markings of the horse. The dating of this piece is difficult, but certainly it is not later than early Ch'ing and may well be middle Ming (sixteenth century). The type goes back to the horses of the Ming tombs (i.e. ca. 1400).

Exhibited: International Art Treasures Exhibition, Bath, England, Aug. 11—Sept. 8, 1973.

Published: *Connoisseur*, vol. 178, no. 716 (October, 1971), illus. on cover.

40. Reclining Horse

China; Ming Dynasty (1368–1644) or slightly earlier
Brown lacquer; H. 8 in., L. 14 in.

illus. p. 57

A long-maned horse, his head turned backward over his left shoulder, reclines on folded legs. Details of the hair are brushed in with black and tan lacquer, and the hooves are black. The carving and the manner of representation are comparable to large jades of the period (see No. 39), but this lacquer example is, so far, unique. There is a remarkably similar jade horse in the Fitzwilliam Museum, Cambridge (acc. no. 034–1946).*

Formerly Fritz Low-Beer Collection.

* The author is indebted to Mr. J. P. Palmer, Keeper of Applied Arts, for this information.

41. Tray with Landscape Design

China; Ming dynasty, probably reign of Yung Lo, 1403–1424
Carved cinnabar lacquer on wood (or cloth?); Diam. 13⅝ in.

The foliate rim is composed of ten floral panels, each containing two flowers, and serves as the outer decoration on both sides of the tray. Under the flowers a yellow ground is visible. Figures on the terrace of a palace in a landscape are portrayed in the center of the tray. The use of a trio of diaper patterns to symbolize ground, water, and sky in this landscape occurs elsewhere on Yüan lacquer (see the small, round box inscribed "Chang Ch'eng" in *Wen-wu ts'an k'ao tze-liao* [Reference Material on Chinese Culture] [Peking], no. 10, inside back cover). There is an incised reign mark, *Yung-lo nien hao* on the back of this dish.

Published: Lee and Ho, *Chinese Art Under the Mongols*, no. 296; includes bibliography of numerous publications of this important lacquer.

Formerly Fritz Low-Beer Collection.

42. Temple on a Mountain Ledge
By K'un-ts'an (Shih-ch'i) (active second half of
the seventeenth century)
China; Ch'ing dynasty, dated 1661
Hanging scroll, ink and color on paper; H. 33½
in., W. 18¾ in.

The dusky color, ropy textures, and complex mixture of trees, clouds, and rocks are characteristic of the artist's mature work. K'un-ts'an (Shih-ch'i), known with Tao-chi (Shih-t'ao) as one of the "two stones" (two *shih*) because of the occurrence of the syllable in their names, was one of four leading individualist scholar-painters who lived at the end of the Ming dynasty, the others being Kung Hsien and Chu Ta. The painting carries an inscription by the artist himself, describing his search for this mountain, and is signed and cyclically dated in accordance with the year 1661.

Published: O. Sirén, *Chinese Painting: Leading Masters and Principles* (London, 1958), vol. VII, p. 365.

Formerly Walter Hochstadter Collection.

43. Mei-p'ing (Plum Vase)
China; Ch'ing dynasty, mark and reign of Yung
Cheng, 1723–1735
Porcelain with *famille rose* enamels; H. 13½ in.

Vivid but delicately painted pomegranates, cherries, and peaches, the latter emblematic of marriage and spring, decorate the vase. The "plum" shape, first developed by Sung potters, was thought to be especially suited to flower arrangements. Six characters within a double circle in underglaze blue indicate mark and reign of Yung Cheng, 1723–1735.

Formerly H. R. N. Norton Collection.

44. Pair of Famille Rose Bowls
China; Ch'ing dynasty, mark and reign of Yung
Cheng, 1723–1735
Porcelain; Diam. 5⅝ in.

Decorated in *Ku-Yueh-Hsüan* (Moon Pavilion Ware) style, the bowls display peonies colored in pink, lilac, and shaded tones of yellow and green, growing from blue rocks among small blue daisy-like flowers; two insects hover above the flowers. On the bottom of each bowl is the six-character mark of the Emperor Yung Cheng, enclosed by a double circle.

The same two-line poem, with seals, in pink enamel appears on one side of each bowl:
> Seen as a whole, it resembles
> > the shadow of the moon in the sky,
> But its rich fragrance
> > is that of the peonies in the field.

(*Wan*, the word used for "field" in this instance, is a carefully selected homonym for "bowl.")

45. Figurine
Japan; late Jomon period, ca. 1200–200 B.C.
Gray earthenware with some black reduced areas,
traces of red pigment on the headdress;
H. 9¾ in. *illus. p. 65*

Extraordinary stylization and abstraction are characteristic of later Jomon (cord-figured) objects. The name refers to the technique used for producing rough surface textures on the pottery by means of a corded pad. The meaning of the patterns is unknown, if indeed they have meaning— J. E. Kidder suspects that they do not (see *Early Japanese Art* [Princeton, 1964], p. 15). The current rise to fame of Jomon earthenware is in part due to its antiquity—before 3000 B.C. in the earlier examples—and to its stylistic compatibility with modern aesthetic ideas. The present example is much like one from Kamegaoka, Aomori Prefecture (see K. Shoten [ed.], *Pictorial Encyclopedia of Oriental Arts, Japan* [New York, 1969], vol. 1, gravure pl. 18).

46. Haniwa Figure of a Man
Japan, Ibaraki Prefecture; late Kofun period,
sixth-seventh century
Clay; H. 56 in.

This *haniwa* (circle of clay) figure has an extremely tall miter-shaped cap, which is decorated with a lattice pattern. His elaborately braided hair, emerging from beneath the cap, curves upward on his shoulders, and repeats the line of the up-turned flaps. Both arms project forward stiffly. The upper garment, which flares out broadly from a tightly cinctured waist, is decorated in front with a sickle; below it are voluminous patterned trousers, pulled in at the knees. There are numerous restorations and repairs, as is characteristic of most excavated *haniwa*.

Published: F. Miki, *Haniwa* (Rutland, Vt., and Tokyo, 1958), pl. 57.

47. Box Cover
Japan; Tempyo period, 710–794
Gold and silver inlays in lacquer on leather
(*heidatsu*); H. 3¾ in., L. 16¼ in., W. 13¼ in.

This *heidatsu* work is one of the most important early Japanese objects in any Western collection. The rare technique was derived from T'ang China (see No. 24), and it is now represented almost solely by the decorative art objects in the Shoso-in and Horyu-ji, Nara. The design on this box cover combines phoenix, floral, and cloud motifs. The closest comparison, in the same format, technique, and medium, is the well known box in the Shoso-in with a similar but less formal design (see J. Harada, *A Glimpse of Japanese Ideals* [Tokyo, 1937], pl. 66). The central rosette on the top is related in design to the unique enameled mirror in the same collection (see *Pageant of Japanese Art* [Tokyo: National Museum, 1952], vol. IV, fig. 76).

Formerly T. Masuda and Kuhara Collections.

48. Fudo Myo-o (Acala)
Japan; late Fujiwara or early Kamakura period,
late twelfth-early thirteenth century
Wood (*yosegi* technique) with polychrome and
kirikane; H. 19¼ in.

Several symbolic attributes which are usually found with the image of Fudo (The Immovable) have been lost: the sword is missing from the right

hand and the noose from the left, as is the flaming mandorla which would have been placed behind the figure, and the rockery base. The deity is one of the five Myo-o (Kings of Light [Knowledge]) and his fierce aspect expresses anger against all forms of wickedness. He was particularly revered in Japanese Esoteric Buddhism, in keeping with the teachings of Priest Kukai (Kobo Daishi, 774–835). Fudo was represented in numerous ways—standing, sitting, running; colored red, blue, yellow, etc.—and some of the most vigorous and skillful sculptures of Buddhism embody his form. This example is worked in *yosegi*, a technique in which several blocks of wood are carved and joined, and is decorated in polychrome and cut gold (*kirikane*). Its comparatively gentle aspect and the self-contained, even elegant form are characteristic of late twelfth or early thirteenth century Japanese examples.

49. Shakyamuni
Japan; Kamakura period, 1185–1333
Wood (*yosegi* technique) with paint and *kirikane*;
 H. 47 in. *illus. p. 68*

While the image retains its lotus base and faceted stand, it is missing the mandorla. The right hand is raised in *vitarka* (teaching) *mudra* and the lowered left hand makes the same gesture. The type is based on that of the sculptor Kaikei, who was active in the first quarter of the thirteenth century. Refined knife and chisel work is particularly evident in the face. The eyes are inlaid with painted crystal, a technique begun in the early Kamakura period.

50. Nyoirin Kannon
Japan; late thirteenth-early fourteenth century
Wood (*yosegi* technique) with color and *kirikane*;
 H. 19 ½ in.

Nyoirin Kannon (in Sanskrit, *Cintamanicakra*) is particularly important for the Esoteric Buddhist sects, the most famous image being the early Heian figure at Kanshin-ji (see T. Sawa, *Art in Japanese Esoteric Buddhism* [New York, 1972], fig. 9). The present six-armed image is extremely well-preserved, although it is missing its flaming mandorla and its four attributes: rosary, jewel lotus, flower lotus, and *cakra* (wheel and its crown). The facial type derives from the art of Kaikei.

51. Pair of Komainu (Korean Lions)
Japan; fourteenth century
Wood, carved, gilded, and polychromed;
 H. 13 ½ in.

These *Komainu* (so called in Japan because of their legendary origin in Korea) are reported to be from the Hayatama Shrine in Kumano, Wakayama prefecture. Other examples of *Komainu* in the United States are in The Cleveland Museum of Art. The preservation of the present examples is uncommonly fine for Shinto wood sculpture of this period.

Published: *Kobijutsu: A Quarterly Review of the Fine Arts*, no. 30 (June, 1970), p. 134, note by S. Kaido, illus. p. 119, 120.

52. Dainichi Nyorai
Japan; Kamakura period, 1185–1333
Hanging scroll, color on silk; H. 43 ½ in.,
 W. 32⅝ in.

Dainichi (in Sanskrit, *Vairocana*) is the Buddha of the Center, the Sun, in the Diamond World (*Kongo-kai*) of Esoteric Buddhism, the Diamond World being that symbolic representation of things as hard, clear, and eternal as a diamond, as opposed to the Womb World (*Taizo-kai*) of material things. The delicate color, fine red-line drawing, and the three joined sections of the silk ground indicate a date early in the thirteenth century. Silk strips have been added above and below, and the surface is somewhat abraded, but the image still retains its hallucinatory, gentle but firm aspect.

Formerly J. Brotherton Collection.

53. Blue Fudo with Attendants
Japan; Kamakura period, 1185–1333
Hanging scroll, ink and color on silk; H. 72 in.,
 W. 45 in.

This representation of Fudo Myo-o (see No. 48) and two of his youthful acolytes (*doji*) is based largely on the well-known twelfth century example at Daigo-ji, Kyoto (see Sawa, *Art in Japanese Esoteric Buddhism*, pl. 126). While the blue in the Fudo image has suffered, the well-preserved colors of the rest of the painting and the large size of the scroll make this an important example of esoteric Buddhist art. The pattern of Fudo's robe, painted to resemble *kirikane*, and the three joined sections of the silk point to a date around 1300, when the older cloth sizes were still in use but when painted gold decoration was being substituted for the earlier cut-gold method. The flaming mandorla, and throne composed of blocks, are particularly effective renderings of traditional forms.

54. Shuya-do (Pavilion in a Beautiful Field)
Japan; early fifteenth century, before 1437
Hanging scroll, ink and very slight color on paper;
 H. 28 ¼ in., W. 11 ¼ in.

This delicate and refined landscape was painted during or just before the time of Shubun, the teacher of Sesshu and the most important monochrome painter of the mid-fifteenth century. In its details, the handling is related to that of a *kakemono* in Seattle, attributed to Shubun. The title of the painting, meaning "Pavilion in a Beautiful Field," was derived from a phrase in a poem by the famous Sung poet, Su Shih (also known by the name of Su Tung-p'o, 1036–1101). Su composed this poem in 1077 after reading a poem written by his close friend and colleague, the historian Ssu Ma-Kuang, about the garden to which Ssu retired after an unsuccessful political career. The inscriptions by Priest Myotaku and by Yoka Shinko, which refer to both poems, are important documents in the history of early Ashikaga monochrome painting; the death of Priest Shinko (of Tofuku-ji) in 1437 establishes the latest possible date for the landscape. According to Tanaka (see below) this is one of five paintings devoted to the subject, three of which include the same inscription by Shinko,

who also inscribed the famous "San-eki-sai" landscape of 1418 in the Seikado Foundation, Tokyo, attributed to Shubun.

Like much fifteenth-century Japanese landscape painting, the present example derives from the Chinese Sung style, in this case its earlier twelfth century phase before the dominance of Ma Yüan and Hsia Kuei in the succeeding century. The types of trees and the general arrangement of the mountains refer to North Chinese prototypes which were passed on through the Chin dynasty to the Yüan painters and thence to Japan. The "cornered" composition at the lower right, however, is reminiscent of Ma-Hsia compositional devices.

Published: I. Tanaka, *Nihon Kai-ga Shi Ronshu* [Collected Essays on the History of Japanese Painting] (Tokyo, 1966), p. 303, fig. 160.

55. Eight Scenes of Hsiao-Hsiang
By Sesson (1504–1589)
Japan; sixteenth century
Handscroll, ink on paper; H. 6¼ in., L. 114 in.

This handscroll, signed and sealed by Sesson at the end, shows the meeting of the Hsiao and Hsiang rivers south of Tung-ting Lake, a favorite subject of Southern Sung Chinese painters. It is surely inspired by the fragments of a scroll of the same subject by Mu Ch'i (Fa Ch'ang) which were in the Shogun's collection in the Ashikaga period. There are also influences from early Ming painters: the lyricism and gaiety of Sesson seen here can be compared with the famous small "broken ink" landscapes in the Inoue and Ise collections (see *Catalogue of Art Treasures from Japan* [Boston: Museum of Fine Arts, 1936], nos. 63, 64). The present scroll left Japan in the early twentieth century. It was exhibited at the Tokyo National Museum in 1973.

Published: I. Tanaka, *Sesshu-Sesson*, in *Suiboku Bijutsu Taikei* [Complete Collection of Ink Monochrome Paintings] (Tokyo, 1973), vol. VII, pl. 108.

Formerly Bing Collection.

56. The Four Seasons
Attributed to Kano Motonobu (1476–1559)
Japan; Muromachi Period, 1392–1573
Pair of six-fold screens, ink and slight color on paper; H. 61 in., W. 142⅛ in. each screen

The composition moves from right to left through the four seasons: spring appears on the right (new willows, early flowering cherry trees), summer on the left of the first screen; fall on the right of the second screen, winter on the left. The attribution to Motonobu is supported by stylistic comparisons with the screens from the Reiun-in (see T. Doi, *Motonobu-Eitoku*, in *Suiboku Bijutsu Taikei*, [Tokyo, 1974], vol. VIII, pls. 5, 24). The density of the composition and the combination of firmness in brush work with fluidity of movement is totally unlike the works either of the contemporary Unkoku school, or of the later Kano school, which created stereotypes of Motonobu's original stylistic contributions. With no signature or seal, the

identity of the artist must remain uncertain, but the quality of the screens and their standing among sixteenth-century examples support the attribution.

57. Beauty Wringing Out a Towel
By Kitagawa Utamaro (1753–1806)
Japan; eighteenth century
Woodblock print; H. 14⅞ in., W. 9⅞ in.

Utamaro created several popular series in the 1790's, consisting largely of half-length portraits (*okubi-e*) of feminine types drawn from the women of the teahouses. The quality of this extraordinary impression of one of the greatest of these designs may be seen by studying the hairs at the nape of the neck and the interplay of fingers and towel. It is identified in the right-hand and center panels of the cartouche as one of the *Fujo Ninso Juppon* (Ten Examples of the Physiognomies of Women), in this instance *Uwaki no so* ("wanton" or "inconstant" type). Printed on a mica ground, it is signed *Soken Utamaro-ga* (Drawn by Utamaro the Physiognomist) in the left-hand section, where the mark of the publisher, Tsutaya Jusaburo, and the seals of the censor and of the collector H. Vever also appear.

Published: C. Vignier and H. Inada, *Utamaro Estampes Japonaises Exposée au Musée des Arts Decoratifs en Janvier 1912* (Paris, 1912), no. 41, pl. XVI; T. Yoshida, *Utamaro Zenshu* (Tokyo, 1941), nos. 112, 115; L. Ledoux, *Japanese Prints Buncho to Utamaro in the Collection of Louis V. Ledoux* (New York, 1946), no. 48; L. Binyon and J. Sexton, *Japanese Colour Prints* (Boston, 1960), pl. 10; K. Shibui, *Ukiyo-e Zuten: Utamaro*, vol. 13 (Tokyo, 1964), p. 49; J. Hillier, *Suzuki Harunobu* (Philadelphia: Museum of Art, 1970), p. 41; *Catalogue of Highly Important Japanese Prints, Illustrated Books and Drawings from the Henri Vever Collection: Part I*, Sotheby & Co. sale catalogue (Westerham, England, 1973), no. 174.

Formerly Henri Vever Collection.

58. Actor
By Katsukawa Shunei (1762–1819)
Japan; late eighteenth-early nineteenth century
Woodblock print; H. 14½ in., W. 9½ in.

There is apparently only a single impression of this design. The tension of the strands of hair, the spareness of the delineations within the face, hands, and chest, combined with the bold border of the robe and its only slightly less bold design, make this expressive masterpiece equal to but different from the actor prints of Sharaku. This is possibly the actor Arashi Ryuzo; the absence of a *mon* (crest) precludes positive identification. The print is signed *Shunei ga*; the mark of the publisher, Tsuruki, and seals of the censor and of H. Vever also appear. The ground is blue, faded.

Published: A. Maybon, *Le Theatre Japonaise* [Paris, 1925], pl. 31; catalogue of the *Henri Vever Collection: Part I*, no. 136.

Formerly Henri Vever Collection.

59. Two Actors
By Toshusai Sharaku (active 1794–95)
Japan; eighteenth century
Woodblock print; H. 14¾ in., W. 10 in.

Two actors in the popular theaters of Edo are strongly characterized in this double portrait: Nakamura Konozo as the "homeless boatman" Kanagawaya no Gon, is being cursed by Nakajima Wadaemon as Bodara no Chozaemon, or "Dried Codfish" Chozaemon. One of the most original and daring designs in Japanese pictorial art, the print is fully expressive of both decorative and portrait-caricature facets, particularly in the interplay between the rotund stolidity of Konozo and the kinetic angularity of his partner. Strong color contrasts further define the figures against a mica ground; compare the differently printed version in the Metropolitan Museum of Art (L. Ledoux, *Japanese Prints Sharaku to Toyokuni in the Collection of Louis V. Ledoux* [Princeton, 1950], pl. 21). The signature of the artist, *Toshusai Sharaku ga* appears in the upper left-hand corner, along with the mark of the publisher, Tsutaya Jusaburo, and the seals of the censor and of the collector, H. Vever.

Published: J. Kurth, *Sharaku* (Munich, 1922), frontispiece; H. Henderson and L. Ledoux, *The Surviving Works of Sharaku* (New York, 1939), no. 29; catalogue of the *Henri Vever Collection: Part I*, no. 253.

Formerly Henri Vever Collection.

60. Lady and Screen
By Eishosai Choki (active 1785–1805)
Japan; late eighteenth-early nineteenth century
Woodblock print; H. 14¼ in., W. 9¾ in.

Strong vertical lines—the left edge of the girl's figure, her upraised arm, and the green mosquito net on the right—are characteristic of Choki's style. The girl has just risen from bed. A ballad in the cartouche at the top left reads: "Meeting, leaving and forgetting him—until I awoke and thought it was he. But it was only the sleeve of my nightgown." The print, on a background of thin mica over yellow, is signed *Choki ga*; seals of the publisher, Tsuruki, and of H. Vever also appear. Published: Vignier, Lebel and Inada, *Yeishi Choki Hokusai ... Estampes Japonaises Exposées au Musée des Arts Decoratifs en Janvier 1913* (Paris, 1913), vol. v., no. 108, pl. XXXVI; catalogue of the *Henri Vever Collection: Part I*, no. 266.

Formerly Henri Vever Collection.

61. Blue and White Jar
Japan; late seventeenth century
Porcelain, *Imari* ware (?); H. 18¾ in.

A porcelain from the Arita region of Bizen, probably *Imari* ware, the jar is painted in the *Kakiemon* style of that area, with overglaze enamel on a soft white ground. The cobalt pigment characteristic of the period is used to render both the scroll design on the neck, and the chrysanthemums, cherry blossoms, and birds of the central scene.

Published: *Sekai Toji Zenshu*, vol. IV (Tokyo, 1956), pl. 91.

62. Bottle-shaped Vase
Japan; late seventeenth century
Enameled porcelain, *Kakiemon* style; H. 15¾ in.

Chrysanthemums, rocks, and birds are painted in the restrained *Kakiemon* style (cf. Nos. 61, 63), with overglaze colored enamels on white porcelain. A bottle of similar design and shape is illustrated in *Sekai Toji Zenshu*, vol. IV (Tokyo, 1956), color pl. 14.

Published: R. S. Cleveland, *200 Years of Japanese Porcelain* (St. Louis: City Art Museum, 1970), no. 89; illus. on cover.

63. Pair of Mandarin Ducks
Japan; late seventeenth century
Enameled porcelain, *Kakiemon* style; Drake,
 H. 5 in., L. 7⅝ in.; Hen, H. 4½ in., L. 7⅜ in.

The brilliant coloration of the drake—blue, turquoise, yellow, red, brown, and black—contrasts with the more somber browns and black of the hen. The pair may well imply conjugal felicity, in keeping with their usual meaning in Far Eastern decorative symbolism.

64. Plate with Chrysanthemum Design
Japan; late seventeenth century
Enameled porcelain with underglaze blue,
 Nabeshima ware; Diam. 7¾ in.

A design of pink and red chrysanthemums with yellow, green, and blue leaves decorates the white ground of the plate's interior surface. The exterior has a three-part underglaze blue decoration of six medallions with flowing ribbons. A plate from the same set is in the National Museum, Tokyo.

Published: *Sekai Toji Zenshu*, vol. IV (Tokyo, 1956), pl. 126, lower.

65. Double-Gourd Vase
Japan; seventeenth century
Enameled porcelain, *Kutani* style; H. 10¼ in.

The lower bulb of the vase is enameled in a strong palette of green, aubergine, blue, yellow, and dark iron-red; a pine tree grows from angular rocks, a flowering plum shows yellow flowers and aubergine trunk, and red diaper clouds rise from the red line border as the vase swells toward its base. Red lines also border the upper register, which is decorated with a gourd vine. The waist is tied with a simulated cord, and the neck is modeled to imitate a section of bamboo, with a small twig growing to one side. The foot-rim is roughly finished. An old label on the bottom states that this piece was exhibited "Oriental Ceramic Society Meeting, London, 9/11/37."

Published: Cleveland, *200 Years of Japanese Porcelain*, no. 51, p. 66.

66. Dish on a High Foot
Japan; seventeenth century
Enameled porcelain, *Ko* (Old) *Kutani* ware;
 H. 4 in., Diam. 11½ in.

The chrysanthemum and gourd design is in aubergine, green, mustard yellow, and iron-red colors,

echoed in the palette of the traditional textile and armor patterns of the border gadroons. On the exterior surface, overglaze blue floral sprays appear above a black star interlace covered with green enamel, which decorates the high foot. Faint underglaze blue lines are used to demarcate the major fields of decoration. Inside the foot, half of the base is unglazed and reveals a pink-gray burn on an off-white body. Examples comparable to this unusual *Kutani* shape can be seen in *Toki Zenshu*, no. 8 (Tokyo, 1958), pls. 14, 15, 57.

67. Tea Jar
By Nonomura Ninsei (active before 1650 and
 after 1677)
Japan; seventeenth century
Stoneware; H. 12 in.

A large four-eared stoneware jar of tea storage shape (*chatsubo*) is decorated in overglaze enamel, with dark aubergine crows (one with touches of silver) among blue, green, and gold rocks and green bamboo. Two of the birds are fighting as others swoop toward them; one stands cawing on a rock. The jar is stamped "Ninsei" on the base. This is one of Ninsei's most decorative and asymmetrical designs, comparable to the well known Wisteria Vase (*Toki Zenshu* [see below], pls. 8, 9). It derives from the great decorative compositions of the early Kano and later Rimpa schools of painting. The jar was formerly registered as an "Important Art Object" in Japan.

Published: *Sekai Toji Zenshu*, vol. v (Tokyo, 1956), pl. 23; *Toki Zenshu*, no. 24 (Tokyo, 1960), pl. 17.

68. Celadon Bowls and Saucers
Korea; Koryu dynasty, 918–1392
Porcelain; Saucers, Diam. 6¼ in.; Bowls,
 Diam. 5¾ in.

Paired flower-shaped bowls and saucers with lobed sides are covered with a pale blue-green celadon glaze. There are three spur marks on each base. Some unintentional crazing has occurred. The style was inspired by the Chinese Imperial Ware of Northern Sung (*Ju Yao*).

Published: *The Art of the Korean Potter* (New York: The Asia Society, 1968), illus. p. 72, nos. 28a and b, and p. 15, bowl only; G. St. G. M. Gompertz, "Seventeen Centuries of Korean Pottery," *Apollo* (August, 1968), pp. 104–113, pl. XXVIII, fig. 3; *Tosetsu* [Journal of the Japan Ceramic Society] (May, 1965); *Burlington Magazine*, vol. LVI (April 1930), p. 186 shows a similar example.

69. Maebyong (Vase)
Korea; Koryu dynasty, 918–1392
Celadon-glazed porcelaneous stoneware;
 H. 15⅛ in.

The large size, watery blue-green glaze, and simple bold shape of the piece make it an outstanding example of pure ceramic art. This type of flower vase derives from China, where it was termed *Mei-P'ing* (cf. No. 43). Throughout the Koryu dynasty it was popular among potters, who di-

verged in distinctively Korean ways from the original formal and decorative concepts (see *The Art of the Korean Potter*, pls. 37–39).

70. Vase
Korea; Yi dynasty, 1392–1910
Porcelain; H. 17½ in.

Pine, bird, and floral designs in pale underglaze blue decorate this large porcelain vase. The lip was damaged before glazing and then glazed over, with the nonchalance typical of the Korean potter. Compare the size and shape to that of the example reproduced in *Sekai Toji Zenshu*, vol. XIV (Tokyo, 1958), pl. 12.

Published: *The Art of the Korean Potter*, p. 128, no. 99, illus. p. 55; Gompertz, "Korean Pottery," *Apollo*, illus. on cover.

Credits

Catalogue designed by Joseph del Gaudio
Set in Monotype Plantin and printed by A. Colish, Inc., Mount Vernon, N.Y.
Bound by Sendor Bindery